"A scintillating look at bodily harm in art and society, from Buster Keaton to *Jackass*, which puts the late 1990s and 2000s in its rightful place as a historically and culturally important moment while showing how capitalist society is forever a sadomasochistic death cult. Snow is witty, funny and sharp as a knife."

CAMILLA GRUDOVA, AUTHOR OF *THE DOLL'S ALPHABET*

"With her sharp insight and ferocious sense of fun, Philippa Snow is the rare critic with the daring necessary to juxtapose *Jackass* and feminist body art, to probe their entangled strains of suffering and liberation. These essays are feats of intellectual agility that feel eye-opening, risky, and all too relevant to our half-mad moment."

ALEXANDRA KLEEMAN, AUTHOR OF *YOU TOO CAN HAVE A BODY LIKE MINE*

"Snow writes with such kinetic, sensory power here, alongside her characteristic, roving intelligence, that I felt I'd (somewhat queasily) witnessed, as well as read, this gripping exploration of pain and performance. *Which As You Know Means Violence* is as smart, fearless and funny as its many sensitively drawn subjects. Brilliant."

OLIVIA SUDJIC, AUTHOR OF *ASYLUM ROAD*

"The best book I've read on art and pain since Maggie Nelson's *Art of Cruelty*, and a worthy successor to that work."

JOANNA WALSH, AUTHOR OF *GIRL ONLINE*

T0061965

WHICH AS YOU KNOW MEANS VIOLENCE

WHICH AS YOU KNOW MEANS VIOLENCE
ON SELF-INJURY AS ART AND ENTERTAINMENT

PHILIPPA SNOW

Published by Repeater Books

An imprint of Watkins Media Ltd

Unit 11 Shepperton House

89-93 Shepperton Road

London

N1 3DF

United Kingdom

www.repeaterbooks.com

A Repeater Books paperback original 2022

1

Distributed in the United States by Random House, Inc., New York.

ISBN: 9781913462468

Ebook ISBN: 9781914420825

Printed and bound in the United Kingdom by TJ Books Ltd

For Thogdin

CONTENTS

INTRODUCTION

In Slavoj Žižek's eccentric, discursive essay-film *The Pervert's Guide to Cinema*, there is a passage in which he analyses a scene from an unfairly maligned, often misappropriated film, David Fincher's 1999 anti-capitalist, anti-masculinity satire *Fight Club*. Onscreen, Edward Norton's character is in a meeting with his boss, and is pummelling his own face with his fist with such extraordinary force that his entire body is thrown, doll-like and loose-limbed, through the plate glass of a table. Because Žižek argues that the cinematic arts are automatically perverse, the screen "teaching us not what to desire, but *how* to desire," he is thrilled by Fincher's staging of the scene — the way it transmutes self-harm into an unsettling act of courage and self-advocacy, with Norton's former office drone smashing his way out of a somnambulist haze by using his own body as collateral. "Far from standing for some kind of perverted masochism or reactionary fantasy of violence," Žižek offers eagerly in voiceover, "I think this [scene] is what liberation means. In order to attack the enemy, you have to beat the shit out of yourself: to get rid in yourself of that which attaches you to the conditions of society."

When Žižek's film was first released in 2006, I was an art student, and his provocative suggestion that an act of self-destruction could be liberatory, even empowering or politically progressive, struck a chord because it might as easily have been applied to another phenomenon from my then-recent youth: the show *Jackass*, an equally bro-ish showcase of self-injury

just as beloved by male lunkheads, which was unleashed on an unsuspecting public in the year 2000. Because common sense dictates that hurting oneself is an idiotic act rather than one that can be radical, meaningful or creatively fulfilling, and because the players themselves were quick to distance themselves from performance artists on the grounds that categorising oneself as such was unforgivably pretentious, I had only been vaguely aware of the show when it first began to air, seeing it as a stupid joke for boys. Later, with the benefit of an arts education, I found it harder and harder to tell the difference between what Johnny Knoxville *et al.* did and what, for instance, Chris Burden had done in 1971 when he enlisted an anonymous friend to shoot him in the arm as what he called a commentary on "a sort of American tradition of getting shot." Wasn't *Jackass*, in its way, a kind of commentary on the directionless, uninsured and broke American slacker's own tradition of, metaphorically speaking, getting kicked extremely forcefully in the balls?

For reasons I have not yet had unravelled for me by a qualified therapist, I have always been drawn to extremity in art and culture, reasoning that an intellectual shock can restore clarity to the mind. Logically, there is no more extreme material for an artwork than the body, the line between work and artist melting into nothing in a way that suggests either true commitment or insanity depending on the audience's viewpoint. Who could not be at least mildly interested in the individuals who decide to work in this particular medium? Nearly a decade after first seeing Žižek equate hurting oneself with the possibility of liberation, I found myself fascinated by a young YouTuber named Paige Ginn, who became an internet sensation in the 2010s for her repeated staging of extremely violent falls in public, the result halfway between

a slapstick pratfall and a stunt. Even though Ginn did not technically see what she was doing as a work of art, it seemed to me to be as bracing and as elegant a challenge to the myth of feminine delicacy as Marina Abramović once posed by allowing audiences to menace her with weapons. What made this long-running train of thought finally crystalise into the impetus to begin writing this book in the spring of 2020, I can't say, although it happened to coincide quite accidentally with the start of an unusually painful period in contemporary history. I do know this: that I wanted to know what allows a person to develop the kind of relationship with intense pain that permits this kind of dangerous self-expression, and that I was also curious as to the effect that the performer's gender — with specific reference to the stereotypes often applied to heterosexual, cisgender men and women with regards to pain and strength — has on the reception of a work that uses self-harm as its medium. These subjects, along with two more enquiries (one about the relationship between pain and humour, and one about the theoretical possibility of death itself being presented as an artwork) form the basis of *Which as You Know Means Violence*. Rather than being an academic text, it is, I hope, just as eccentric and discursive as that documentary by Žižek — maybe its own kind of pervert's guide, examining the possibility of pain as an effective vehicle for profundity, liberation, feminism, subversion, eroticism, humour and divinity every bit as interesting as pleasure.

I. SOME PEOPLE ARE LIKE COMETS

Three weeks before he died, Hunter S. Thompson left a message on the answering machine of another, less literary all-American countercultural fuck-up: Johnny Knoxville, the man best-known for his role in the creation of the television series and film franchise about self-injury, *Jackass*, and less known for a career in Hollywood that peaked with an unedifying film based on the 1980s show *The Dukes of Hazzard*. Thompson, the genius gonzo journalist whose mythic drink and drug consumption and percussive, breakneck prose occasionally overshadowed a keen eye for the particulars of politics and sport, had recognised a kindred spirit in the cocky, Kentuckian stunt *artiste* after the two of them went on an all-night bender in September 2005, in New Orleans. Knoxville, who for some mysterious reason cast aside his Pynchonian real name, P.J. Clapp — an appellation that seemed tailor-made to fit a stunt-performer in a circus — in favour of a salute to his home state, had idolised Hunter S. Thompson more or less since adolescence. By the time they spent that night together in Thompson's hotel room, drunkenly, bromantically reading selected passages from his Hawaiian odyssey *The Curse of Lono* to each other, Johnny Knoxville had become extremely famous, a putative redneck playboy whose idea of play was hazardous, extending to the kind of fun and games

where somebody is apt to lose an eye. Magazines, noting his sharp-toothed, wolfish grin, likened him to a young Jack Nicholson — a comparison that would doubtless have pleased most men, but which would not have lived up, in Knoxville's eyes, to being the heir to Thompson's title as the sickest, most erratic documentarian of American life ever to earn the status of a household name.

In his very early twenties, Knoxville filmed a segment for the cult skate magazine *Big Brother* in which, standing in a neat suburban garden that seemed certain to belong to someone's mom, he sprayed himself with Sabre Red, shocked himself with a 120,000-volt electric taser, and then drove out to the desert to put on a bulletproof vest and shoot himself with a .38 calibre Smith and Wesson at immediate range. The footage, rough and un-reconstituted as a snuff film, is at once a prototype for the aimless and unavailing self-destructiveness of early *Jackass*, and an accidental echo of a number of prominent 1970s body art performance videos, most notably Chris Burden's *Shoot*. Knoxville, who can be heard being called P.J. by off-camera friends — "P.J., it's done", one of them says, although he might also be saying, not wholly inaccurately, "P.J., it's dumb" — introduces himself in one languorous breath as "Johnny Knoxville, United States of America," as if he were not a man at all, but an extremely scruffy metaphor: a walking, talking, self-abasing national id. Mailing the video to Thompson, he had been surprised to receive an encouraging phone call in response. A little later, the two met for the first time, fleetingly, at the Viper Room, the younger man admitting to having been "footloose, and a little overzealous" — an uncool and eager novice in the presence of a master. "He suspects," *GQ* reported, perhaps underestimating how difficult it would be to perturb Hunter

S. Thompson, "Thompson told his handlers to 'keep that guy away from me.'"

Evidently, if Thompson felt any revulsion for the neophyte stunt actor, he renounced it over time; the sins of the father, when it came to bad behaviour, far outweighed those of the son. The two men shared a proclivity for some things — large quantities of alcohol, illegal and dangerous fireworks, lurid tiki shirts, and a very specific style of aviator shades that looked on Knoxville like a white-trash pastiche made by Gucci, and on Thompson like the glasses of a pervert — and a disdain for some others — personal safety, formal dress codes, what might loosely be referred to as The Man — and they were altogether two peas in a pod, in Thompson's mind, when it came to possessing something called "freak power." Knoxville repeated that message from his answerphone to an interested journalist in 2005, putting on "a scratchy Dr. Thompson voice." That he appeared to remember the words verbatim was evidence of his awe, a lasting sense that he had somehow been inducted into greatness. "Johnny," Thompson had reportedly informed him,

we were just sitting here talking about you, and then we started talking about my needs, and what I need is a 40,000-candlepower illumination grenade. Big, bright bastards, that's what I need. See if you can get them for me. I might be coming to Baton Rouge to interview [imprisoned former Louisiana governor] Edwin Edwards, and if I do I will call you, because I will be looking to have some fun, which as you know usually means violence.

"Fun," for most people, does not usually mean violence.

It is difficult to say what makes a person see the world the way Hunter S. Thompson did, except to guess that it may have something to do with an extreme attunement to the dark vibrations of a certain kind of American life, a folk song pitched at a dog-whistle that could only be detected by those who self-identified as outsiders. "What do you say," he had written in the Eighties, ruminating on the dual threats of the spread of HIV and acid rain, "about a generation that has been taught that rain is poison and sex is death? If making love might be fatal and if a cool spring breeze on any summer afternoon can turn a crystal blue lake into a puddle of black poison right in front of your eyes, there is not much left except TV and relentless masturbation. It's a strange world. Some people get rich, and others eat shit and die." Knoxville, born in 1971 — the same year Chris Burden made *Shoot* — certainly belonged to the generation Thompson was describing, making it entirely fitting that he and his *Jackass* cohort would get rich by masturbating, eating shit, and almost dying on a television show watched by 2.4 million viewers. Bloody, dumb, aggressive, screwy, simultaneously masculine and childlike, drenched in vomit and in semen, it is strange to think of *Jackass* having first aired in 2000 in light of its nihilistic attitude to modern American manhood, life, and work — it too obviously resembles a post-9/11 show, with its giddy violence sometimes mirroring the helpless, hopeless mania that follows serious trauma. Notionally and geographically, it exists halfway between Venice Beach and Never-Never Land, making its bloodied knees and noses feel like natural by-products of its arrested, unpoliced environment. (Lest we forget: in J.M. Barrie's *Peter Pan*, it is heavily implied that Peter murders his Lost Boys when they commit the crime of starting to reach puberty.) Its approach to injury is near-balletic, each

sketch an elegant *pas de deux* or *trois* or *quatre* or *cinq* in which agony, and not ecstasy, is paramount. The pain — its white-hot, cattle-branding brilliance — is the point. The celerity of its pacing, fast and hard and engineered to appear loose, echoes the structural integrity of, say, the greatest hits of the Ramones: a pummelling, driving rhythm, built to induce something like an amphetamine rush, as carefully constructed as the sugariest single by a Spector girl group.

Early in its debut season, a baby-faced Johnny Knoxville can be seen wearing a shock-collar for dogs with his Ramones shirt, his incongruous prettiness lending him the unlikely air of a 2000s stoner dropout who has been abruptly dropped into a punky, prankish remake of *Salò, or the 120 Days of Sodom*. "We're going to convince [sound engineer Rick] Kosick that this is a piece of audio equipment," he says straight into the camera, his tone as temperate and chill as if this were not an assault, but an experiment. "Unbeknownst to him, *he's gonna get shocked*." The way he says these last four words — his Southern-fried Tennessee accent turned up *just so* and feminised roughly twenty-five-per-cent, so that he sounds a little like Vivien Leigh as Blanche DuBois — unwittingly cements the mood of *Jackass* as a Freak Power franchise: an eighteen-hour fuckaround whose target audience had been young, disaffected men who wanted to watch *other* young and disaffected men affixing mouse traps to their nipples. The men of *Jackass* were frequently, nakedly homoerotic; they were dorky, skinny, more like boys who would be bullied than the alpha males most often seen meting out punishment. Knoxville's crew included Ryan Dunn, Bam Margera, Jeff Tremaine, Brandon DiCamillo, Raab Himself, Steve-O, Preston Lacey and Ehren McGhehey, as well as a host of other daredevils with smaller parts, none of them leading men or

heartthrobs, all of· them cheerfully, grungily fatalistic. These men loved each other madly and fraternally, occasionally kissing, their desire for proximity appearing to arise from the muddling of terror and eroticism inherent in being made aware of one's mortality — what the art critic Leo Steinberg described as "the condition of being both deathbound and sexed." When the lawyers at MTV began suggesting that they could no longer perform stunts that seemed to risk their lives, they grew rebellious, migrating to a medium in which violence is and always has been less taboo than sex, hard drugs, political subversion, or the presence of non-white or unconventionally attractive leads: the movies.

"Fiction," Hunter S. Thompson once told an editor at Knopf, "is a bridge to truth that journalism can't reach." The *Jackass* films — a slickly-made quaternary franchise whose second instalment is, of course, called *Jackass Number Two* — are not narrative so much as expressionist: long runs of sketches that intentionally or otherwise gesture at a bigger, more incendiary message about what it means to be a young man in America beset by the psychic indignities of economic downturn, terrorism, unemployment, hopelessness about one's place in an increasingly dysfunctional society, and distant, quietly raging war. In the first movie, Knoxville rents a mid-range family car, pointedly choosing one whose paintwork is as white as untouched snow, and takes it to a smash-up derby, saying when he hands the car back by way of apology that he quite often "drink[s] and just black[s] out." Later, a far less substantial car — a Hot Wheels toy — is inserted into Ryan Dunn's backside, the setup for a gag about a druggy frat-house orgy gone awry. In the second *Jackass* film, Bam Margera has his ass-cheek branded with a cartoon penis by a sullen cattle rancher, and a nervous Knoxville dons a

sailor outfit to wrestle with anacondas in a ball pool as the soundtrack plays the 1981 single by Josie Cotton, "Johnny, Are You Queer?" (Subtext, by this point, has become sniggering text.) What many of the set-ups have in common is a dark 'n' dumb, seditious take on traditional masculinity — the race-car driver, the cowboyish cattle rancher and the US navy man, all filtered through the sensibility of boy outsiders, never quite sturdy enough to make the team.

Hollywood, a metonym not only for the movie industry but for all things that are too good, too convenient or too bombastic to be real, seemed like the funniest place for these supposedly rough-edged and redneck daredevils to be performing stunts without protection, safety nets, or training. Rarely has a cultural product felt more of the suburbs than the original run of *Jackass*, its dirtbag performers never looking like anything ritzier or more polished than a pack of local skaters who congregate in the car park at a mall. "We're always trying to build a utopian society," Peter Masuch, the chair of cinema studies at St. Joseph's college, once said in an interview with *Newsweek*. "And for the baby boomers, suburbia became that utopia. The flip side is, the utopia never lived up to its promise. People became disenchanted, and then they react[ed] to that with critical and dark depictions." A suburban adolescence, in other words, may have been a contributing factor in the *Jackass* boys' desire to take aim at America by taking aim at each other's tenderest parts: Gen Xers born into the failed utopia Masuch describes, their depiction of the status quo was fated to be dark. "If this isn't cultural terrorism," the provocateur-auteur John Waters wrote in *Artforum* of *Jackass Number Two*, in which he had a minor cameo dressed as a rinky-dink magician, "I don't

know what is." Ultimately, *Jackass* fitted into Waters' legacy as snugly as a Hot Wheels car into a stunt performer's rectum.

John Waters' championing of *Jackass* is not terribly surprising — nobody will ever be as inextricable from the idea of eating shit, however many times the men of *Jackass* did so literally or figuratively. In 2004, Waters cast Knoxville in what has, to date, been his last theatrically released motion picture, also set in suburban America. *A Dirty Shame*, a gross-out comedy about a group of uptight, small-town prudes who hit their heads and end up turning into nymphomaniacs, fulfilled its purpose by being seen by almost no one; one last funny, filthy provocation from an offbeat national treasure. Playing Ray-Ray, a sex-fiend mechanic with a self-professed "hard-on of gold," Knoxville achieves the balance every good John Waters actor hopes to attain in a leading role: a queasy mix of sex appeal and pure revulsion. The film did not end up heralding a move into the arthouse for the stuntman; what it did show was that Waters had identified his most sensual and insoluble quality, a merging of haute American masculinity and knowing, playful deviant drag, underpinned by what was apparently an interest in high culture. "Johnny is great; he's a sweetheart," Waters told an interviewer from a New Zealand newspaper in 2011. "He's sensitive and funny." Knoxville's willingness to, say, wrestle in horseshit seemed at odds with his avowed love of the French New Wave and Flannery O'Connor. (Ernest Hemingway, he would insist, was far "too macho" for his taste.) *Meet Jackass the Sophisticated Dude; You Want Rowdy and Moronic? Johnny Knoxville Is Poised and Bookish, if You Please,* the *New York Times* trumpeted in 2002, noting how at ease he appeared ordering his meal in French at La Grenouille. The following year, the *Times*, alongside anecdotes about him covering his genitals with bee attractant, noted

that Knoxville had been moved to leave his hometown after reading *On the Road*, and that when he first went to LA it had been to write a novel. Every profile seemed to ask a similar question: What is Johnny Knoxville's *deal*?

It would take Knoxville fifteen years to get around to even trying to provide an answer; that the question is, in many ways, the same one underpinning this particular essay makes his revelations on the subject doubly piquant. "I started to think, *Why do I love it? Am I addicted to it? Is it coming from a good place?*" he told David Marchese in 2018. "I don't want to overthink things, but I don't want to underthink them either because in this line of work you only get so many chances… Some other actors do their own stunts, but the difference is that their stunts are designed to succeed." He had been filming *Action Point*, a movie about an unregulated theme park for which he had done his own stunts, ending up with four concussions, whiplash, stitches, a destroyed knee and a shattered wrist, and two-and-a-half broken teeth. One day, blowing his nose after discovering it was bloody, he felt his left eye pop, grapelike, out of its socket — "I was blowing air around my eyeball," he explained, "and pushing it out" — forcing the crew to shoot him only from the right side for six days. He had just turned forty-seven, and if he had looked like Jack Nicholson circa-1970 in the earliest days of *Jackass*, he now looked a little more like a car salesman who had been beaten up by a gang of flunkies over money at the racetrack. It had begun to occur to him that death was not an abstract possibility, but something real, the bloody bloom rapidly wearing off the rose as far as self-harm was concerned, now that a colleague — Ryan Dunn, who crashed his 2007 Porsche 911 GT3 in 2011 and died at thirty-four — had lost his life, and several others had developed debilitating addictions to

painkillers, or dependencies on alcohol, or real-deal longings for annihilation that could not be satisfied by taser guns or vomit omelettes. Somewhere between head injuries on the set of *Action Point*, he had begun to think about his dying mother, and about the way his own children might feel if he ended up sacrificing himself on the altar of a ninety-minute comedy about an unsafe theme-park with a 19% Metacritic rating. He tells Marchese that he realised something: "I may have a little left in me. But for my sake and my family's sake, I should start winding down."

Thus, Johnny Knoxville ended up adopting another popular American pastime, newer than the nation's lust for violence and a little older than its history of stunt performers: he began to see a therapist. "'I don't want to fix the part of me that does stunts,'" he recalls saying. "'Just to get that out in the open... That's what I don't want to fix.'" In that interview with Marchese, he is coy about what drives a man to throw himself into a children's ball-pit full of snakes, or deliberately crash a motorcycle, or split his head open "like a melon" on the concrete floor of a department store, save for saying that some of his impetus to destroy himself is almost certain to emanate from a dark, "unhealthy place." The reader, left to fill in the blanks, invariably imagines some formative, terrible event that shook these strange desires loose — a childhood injury, an accident bloody enough to scar the mind. David Lynch, the dark suburban yin to Waters' camp suburban yang, has said that as a child he saw a naked woman staggering down the road at night outside his house, "in a dazed state, crying." "I have never forgotten that moment," he told Roger Ebert in an interview in 1986. He has not allowed us to forget it, either — in *Blue Velvet*, Dorothy, a nightclub singer and rape victim, is seen stumbling past the verdant, manicured lawns

of her younger lover's neighbourhood stark-naked, evidently in distress. If not all artists make such deliberate connections in their work, re-enacting and restaging these determinative, generative moments as if all art were true crime, it cannot be denied that many of them enjoy gesturing elliptically at their own histories.

"When I was 17 or 18," Knoxville told *GQ* in 2005, "I'd be passed out, and [my father]'d take a hot dog and put it in the microwave for 20 seconds to get it lukewarm, then run it through my mouth. When I woke up, he would act like he was zipping up his pants." Big Phil Clapp, a used car salesman and an inveterate prankster, is a mythic figure in retellings of the early life of Johnny Knoxville: a doting-family-man-cum-emotional-terrorist whose love language was hazing, he encouraged his delicate, sickly son — who suffered allergies and asthma, and who almost died at eight from an unfortunate combination of pneumonia, flu and bronchitis — to punch strangers in the groin as soon as he grew tall enough to land a blow. Clapp's unconventional parenting style clearly imprinted on the boy, convincing him that pranks and stunts could be a bonding exercise, a reinforcement of the love between two men. Whether this early formation of a relationship between masculinity and tenderness and violence proved to be the catalyst for his career, or whether the contextualising bleakness of America in the immediate aftermath of 9/11 crystalised a latent impulse, or both things, only his therapist can say. One is reminded of the curious case of Little Hans, the young boy with a fear of horses famously studied by Freud: the psychologist believed that Hans' terror sprang from an Oedipus complex, the horse and its outsized penis representing the tyranny of the father, combined with an incident in which the child had watched

one of the animals collapse and die after an epileptic fit. Daddy and violence, both, are influencing factors *sans pareil*.

What is certain is that when practitioners turn to self-injury, or to the risk of death, the reasons tend to be one or more from a certain laundry list: trauma, Eros, infamy, national identity or history, parental influence, an interest in religious martyrdom, and war. "Art," Leo Tolstoy wrote in *What Is Art?*, "is a human activity consisting in this: that one man consciously, by means of certain external signs, hands on to others feelings he has lived through, and that other people are infected by these feelings and also experience them." "I feel like the injuries, I share with people," Knoxville told *GQ* in 2021, unconsciously echoing Tolstoy. Though he clarified that what he meant was that his various breaks and scrapes and dick-destroying accidents had happened "in a public way," the implication of a psychic bond between the audience and the stuntman — of the pain, not just the image of its terrible creation, being "shared" — endures. When the pseudonymous critic Uncas Blythe describes the *Jackass* players as "voodoo medics" for post-9/11 American society, he takes pains to underscore the fact that their continued dedication to their practice, bearing pain in perpetuity, is the locus of their power: "The triumph is in density," he says. "There is something uniquely bonding and yet strikingly odd about repeatedly watching *the same people* suffer humiliation, pain, fear and revulsion again and again... Everyone, actor and spectator alike, is bound in an inescapable ritual." Devoting one's life to agony in order to facilitate the exorcism of the dark and restless spirit of the age seems, *prima facie*, like the kind of thing only a madman or a saint would choose to do.

Only one more category — that of the artist — springs to

mind. A little over fifty years ago, in 1971, a fine art student named Chris Burden spent five full days in a locker at the University of California, padlocked in and with no space to move, or sleep. In the locker just above, he stored five gallons of drinkable water, and immediately below, he stored his urine. Barbara, his wife, slept on the floor outside, in case the 60 x 60 x 90cm space became too small to bear, and he "flipped out." He had consulted medical practitioners about the risks of undertaking the performance and had been warned that paralysis and blood clots were both possibilities, adding a further dangerous frisson; his extreme vulnerability bred paranoia, an irrational fear that someone might attempt to injure him while he sat motionless and trapped. Other students came and went, sometimes conversing with him and sometimes beating the locker with their fists, and although Burden could hear everything they said, he could not see them: he reported that *because* they could not see him, they occasionally revealed a little more than they had meant to, conversations sometimes turning into something that resembled two-way talking therapy. In the documentary *Burden*, released in 2017, there is an audio recording of him talking to two giggling female students while in situ. "I'm an artist," he says boastfully, as if he recognises that a long career of some importance, underscored by a devotion to this very brand of suffering and denial, had been ushered into being. "It's an art piece." When one girl asks if he feels "like a hamster or something," he laughs. "Sure do," he admits, "I feel like an animal."

If being confined for the duration of his college show made him feel like an animal, it also helped Burden announce himself as an extreme new voice in art, divisive and electrifying. (In the segment where the locker piece is being discussed by talking

heads in *Burden*, he's described as "phenomenal, a magician" and "about as fucking dumb as you can be" by fellow artists Larry Bird and Billy Bengston within seconds of each other.) When the *New Yorker*'s Peter Schjeldahl asked him later why he did it, he said that he wanted to be taken seriously as an artist, as if self-inflicted suffering and solitary confinement were acknowledged shortcuts to artistic legitimacy rather than signs of mental illness. Like most geniuses, he knew that the ability to transform inner turmoil into an external metaphor could make great art, the personal becoming broad and universal as it passes through the clean, refracting prism of a concept. The physical aspects of his work appear, at first blush, to be as senseless and unthinking as most violence; what allows them to endure as artworks is the way that this appearance is itself reflective of, and thus elucidative of, an American tendency towards sadism and brutality, spilling over into sadomasochism. "Everybody has fantasised about being shot, either consciously or unconsciously," he claims in *Burden*. "It's as American as apple pie, the idea of being shot or of shooting people." Or, as another man once said shortly before firing a .38 calibre bullet squarely at the centre of his chest: "Hi, I'm Johnny Knoxville, United States of America."

Whether or not Burden's bold assertion that we have all fantasised about ending up on the wrong end of a firearm holds water, he is right that there is something typically American about the championing of guns. Born in Boston one year after the end of WWII, he began his practice in the final years of Vietnam, ensuring that his early life was steeped in war. At twelve, he had been operated on without anaesthesia after a traffic accident, leaving him with a devil-may-care attitude to pain. "The Jackass Decade, which began with the national wound of 9/11 and ended a hair early with the fiery crash of

Ryan Dunn on June 20th, 2011," Uncas Blythe wrote in 2015, "was a shamanic displacement of war trauma onto what looked to the untrained rationalist eye like idiot clowns, but who in fact were voodoo medics for the whole of American culture." The same might be said of Burden, his perfervid need to break and bend and otherwise wreak havoc on his body an expression of the agony experienced by a nation who could not forget the things they did, for God and country, to civilians and children in a land they did not conquer. Gradually, his work became ever-more fixated on physical discomfort: he filmed himself being shot, being nailed to the roof of a VW Beetle, crawling across broken glass, being kicked down several flights of stairs, etc. — the actions of a masochist or a nihilist or a madman. Never mind that Burden's friend had claimed to be a better marksman than he was, and that the bullet was supposed to sail right past him — never mind that for the 1973 piece where he dragged his naked body, arms bound tightly at his back, across those shards of broken glass, he used the kind designed to crumble rather than to pierce the skin. What Burden induced in the viewer was a sense of his or her continual nearnessness to oblivion, the idea of pain as inescapable and sempiternal. Schjeldahl saw him as a poet, each work capable of being summed up in one or two crisp, elegant lines, as balanced in their lucidity and their power as a haiku. "Burden adventured alone in wilds that aren't outside civilized life but that seethe within it," he wrote in 2015. "He coolly structured convulsive experience."

"I'm not about death and I didn't want to die," Burden told a TV interviewer, "but I wanted to come close, okay?" Such is the paradox of the self-injurious performance artist, not to mention the self-injurious prankster: death preoccupies them, but quite often they are courting it in order to feel or

to demonstrate the fact that they are still alive. The Freudian death-drive, Slavoj Žižek has insisted, has less to do with a desire for self-annihilation than it does with an intense, undying longing to chase pleasure or sensation that remains just out of reach, an "uncanny excess of life." "Humans are not simply alive," he writes in *The Parallax View*, "they are possessed by the strange drive to enjoy life in excess, passionately attached to a surplus which sticks out and derails the ordinary run of things." Burden, in an early TV interview, agreed, but put it differently: "Some people," he shrugged with a casual insouciance, "are like comets. If I go out during a piece, that's okay. I'm not planning on it. If it happened it would be an accident, but that's the unknown." Always, Burden felt the need to push himself, to dare his audience — to prove the burning urgency that marked him out from those who, unlike comets and equally unlike madmen, cared about self-preservation. The famously brilliant and famously unhappy novelist David Foster Wallace, who "went out" by his own hand in 2008 at the dizzying peak of an extraordinary literary career, at the age of forty-six, once said that "dullness" tends to be "associated with psychic pain because something that's dull or opaque fails to provide enough stimulation to distract people from some other, deeper type of pain that is always there if only in an ambient, low-level way." "Most of us," he added, "spend nearly all our time and energy trying to distract ourselves from feeling [that deep pain], or at least from feeling [it] directly or with our full attention." Because American culture, in the 1970s especially, sorely needed a distraction from its memories of war, Burden's seeming lunacy with regards to his personal safety made for stellar interviews, extreme reviews, and performances definitive enough to

successfully rewire audiences' ideas of what could and could not be described as art.

Chris Burden, in light of his understanding of the great American triptych of war, guns, and television, may not simply be one of the best American artists in contemporary history, but one of the *most American* artists in the pantheon of contemporary art. His conviction, frightening and awe-inspiring at once, seemed to push the all-American qualities of brute strength, self-belief and self-promotion to the point of near-religious fervour, as if he were at once worshipful, and someone to be worshipped. "If Burden had been born in the second century instead of the twentieth," the critic Dorothy Sieberling wrote in *New York Magazine* in 1976, "he would today be as much of a church legend as his name-saint, Christopher. In the past few years Burden has been exhibiting all the driving inclinations — and many of the scars — of a fully-fledged martyr of the faith. His faith, however, is not in the power of God, but in the power of Art."

God, hand-in-hand with both art and American warfare, proved to be the guiding force for another mid-Seventies performance practitioner with a major in grand guignol self-injury: the Biarritz-born Italian artist Gina Pane. In 1971, in her Parisian studio, she photographed herself climbing, descending and then re-climbing a ladder lined with knives until her hands and feet were utterly destroyed, a deliberately incendiary act of protest meant to draw attention to the suffering inflicted by the war in Vietnam. Called *Unanaesthetised Escalation*, it shared with many of Pane's works an interest in the iconography of martyrdom, a nod to her enduring fascination with Renaissance art. (*Nomen*, in this instance, *est* extremely *omen*.) "Ecstasies are unforgettable, and they are tyrannical," the nineteenth-century martyr Gemma Galgani once wrote.

"Those who experience them helplessly shape their lives in order to create the possibility of another encounter with the holy." Prolonged agony, and particularly what the sufferer feels is disciplined, worshipful agony, does induce ecstasy, a kind of lightheaded derangement. Like Galgani, who was canonised after her death, Pane remained fixated on the idea of giving herself wounds that resembled the wounds of Christ: in *Sentimental Action*, she embedded rose-thorns in her forearm before slicing through her palm, stigmata-like, with a straight razor. "Injury," she argued, "is a sign of the state of extreme frailty of the body, a sign of pain, a sign that reveals the situation of external aggression, of violence, to which we are exposed."

What she and Burden had in common was a dogged belief in the cleansing and symbolic value of self-injury, its status as a primal language. Still, where Pane adopted the self-abnegating pose of martyrdom, Sieberling's characterisation of Chris Burden as a saint elides the darker, more masculine power that inflects his every gesture — even when he is in danger, he does not seem cowed so much as brutally defiant, as if daring audiences to doubt his potency. In a 1975 performance, he remained on a high platform in a New York gallery for ninety days, invisible to his audience but listening in, allowing them to picture him moving in mysterious ways. Burden, telling Roger Ebert of the *Chicago Sun-Times* that the performance had been "mystical" and "spooky," said he'd overheard a student likening him to something even more blasphemous and dramatic than a saint: "He can hear us," Burden claimed the boy had said, "and he doesn't answer, but he can't help listening. It's like God." It is hardly unusual to paint God, whose generation of the Earth and all its beasts in Genesis can be appreciated even by an atheist as an extremely pretty

metaphor for the Big Bang, as a fine artist. Characterising him as a sinister, omniscient eavesdropper, though — aloof and distant and more interested in listening to strangers' conversations than in actually conversing — makes it far easier to see him as a writer than an artist. Peter Schjeldahl, in addition to categorising Burden as a poet, once described his sense of humour as "too troubling to be funny" — "unless," he clarified, we chose to view it as a result of his being something other than a man or saint: "a cynical God."

Ten years before Chris Burden first confined himself to that 60-by-90 locker at the University of California, a boy named Ron was born into a stone-broke, fervently religious family in the small town of Groton in Connecticut. While it is not unusual for parents to behave as if their children were the centre of the universe, the Athey family took their worship of their sons to an entirely new level — broadly Pentecostal but enamoured of the hippier, flashier parts of Sixties and Seventies spiritualism, they informed Ron from a very early age that he had been born with "the Calling on his life," into "the most important family in the world, chosen by God to kick off Armageddon." By the time he had turned seven, he was being encouraged to lie down out in the desert and attempt to read the clouds like a hallucination or a premonition, a high-stakes interpretation of the classic children's game of looking for familiar shapes. By the age of ten, he had begun speaking in tongues, his parents' parishioners laying hands on him in sermons. He would not be a messiah, his family reassured him, but he would be something close — a John the Baptist figure spreading the impending gospel of his cousin, who would be the second coming, and whose mother, his Aunt Vena, had been informed by the Virgin Mary in a vision that immediately after giving birth to the new Jesus, she would be

rewarded with the chance to marry Elvis Presley. (This being the first half of the Sixties, somewhere between his return to television on the Frank Sinatra special and *Viva Las Vegas*, Elvis Presley was still considered to be at the height of his fame and sexiness, suggesting that the Virgin Mary at least had admirable taste in handsome men.) When Ron failed to learn the automatic writing that had come so naturally to his aunt — who claimed to channel not only her deceased grandmother, but also several saints — his illustrious future in his family's church began to look a little hazier, the clouds foretelling his towering ministerial success suddenly clearing to reveal a sun that looked more like hellfire than like heaven. There was, too, another issue: Ron was gay, a development that did not please the love-thy-neighbour-*unless* sensibilities of his community of Pentecostal Christians. If the Virgin Mary wanted to arrange a marriage between Elvis Presley and a woman who believed, that was Her business; if a boy grew up and felt as though he might want someday to be married to a man who looked like Elvis, too, that was a sin, punishable by damnation.

Even those around him who believed they had the power to predict what might come next by parsing dreams, divining clouds, and having conversations with the souls of saints must have been startled by Ron Athey's eventual career path. He got into go-go dancing, and then sadomasochism, and eventually into an haute-gothic and blood-spattered brand of performance art that somehow merged both of these things with an appreciation for the iconography of Christianity, and of Catholicism in particular. In the queer clubs of LA, he found a world more welcoming than the supposedly forgiving love of God, a community better placed to see the future than the one that had first looked at him and incorrectly seen a minister, and then looked at him and incorrectly seen a

sinner and a pervert rather than a man who happened to like men. "I'm programmed to carry a message," he notes in the documentary *Hallelujah!* "Being a vehicle is the most important thing in my life. It's more important *than* my life." In his teens, he had begun to cut himself in an attempt to sever ties with what seemed increasingly to him like an empty, meaningless religious faith, alternately using pain to shock himself back into life, and to dissociate in order to escape his mounting guilt. As an art practitioner, he found that self-injury offered him a shortcut to transcendence, a bloodletting of the spirit and the soul. "Only people that are emotionally damaged feel the need to tear their bodies inside out," he says later in the documentary. "I believe by doing it publicly, by doing it in theatre, and theatre more related to Greek tragedy than contemporary theatre... It's bearing witness. It's alchemy." "Someone," he adds, making more or less the same point Johnny Knoxville makes about the shamanic potential of self-harm, "has to be in pain for all of us."

In 1985, he became one of the first people he knew to be diagnosed with HIV, and because he feared that dying young had become not just likely but inevitable, he began getting tattooed as regularly as once a week. "Getting inked while HIV-positive caused a huge rift in the tattoo community, [but t]here was an incredible female tattooist, Jill Jordan, who said she already used gloves and sterilized everything and therefore had no problem with it," he recalled in 2015. "Why was it so important to spend the little money I made on ink if I was dying? Because it felt empowering. Because I had a dream that I faced a spirit twin, and our tattoos were finished and we were levitating. Because I still felt healthy and horny. The blood, you could say, was coursing." In his work, it did not course so much as roar: slashing himself, sticking

himself, cutting symbols in his flesh and thrusting objects in his ass, Athey ritualised blood-play until it looked like a sacrament, proving to his audience that life-force as well as God-force filled his veins. "It's strange that most of my work is performance, because part of this frenzy with AIDs is 'oh my God, I'm gonna die in a few years, and I have to leave my mark,'" he says in *Hallelujah!*,

> Was I just some stupid fag who died of AIDs, or was I this troubled boy who never became a minister, and who lashed out and rebelled, and then in between took drugs and had promiscuous sex and contracted a disease and died? It's this frenzy to make it bigger, to make it more, to make it mean something... I see myself as being akin to a teenager slashing at myself. It has finesse but it's a temper tantrum.

In 1994's *Four Scenes in a Harsh Life*, Athey set out to "affirm the gay male body as a site of reverence during the AIDS pandemic." The "harsh life" of the title was, of course, his own: "A *Grapes of Wrath* darkness," he once wrote, "that was fatherless; an institutionalized schizophrenic mother; a fundamentalist Pentecostal upbringing by relatives; a decade of drug addiction, followed by HIV infection." Instantly iconic, *Four Scenes* also garnered controversy because of its liberal use of human blood — at one point, Athey began cutting symbols into his performers' skin, blotting the wounds with paper, and then winching the resulting prints over the crowd on lines of clothes-wire, sparking accusations that there was a risk of HIV contamination for the audience. It hardly mattered that the blood was not Ron Athey's, or that the offending paintings were not wet enough to drip,

despite reports — all queer blood, as far as right-wing media commentators saw it circa 1994, was hazardous material, a conduit for queer disease. The performance took place at the Walker Art Centre in Minnesota, as part of a festival for LGBTQ+ film, meaning that it had received a paltry $150 aid from the National Endowment of the Arts as part of the NEA's funding of the weekend-long event. The idea that taxpayers' dollars had been spent on "dangerous" art became a talking point amongst conservative Americans, who could not bear the thought of innocent observers being tainted by a work whose use of blood had been described by the art critic Mary Abbe as the equivalent of "adding [potentially lethal] blowfish to the buffet of a Japanese restaurant without warning the clientele." "Ron found himself defending a concept — public funding — that he didn't really even understand," a 2007 profile in the *LA Times* reported, "never having then or to this day applied for a public grant in the United States."

More than defending public funding, Athey also found himself required to defend his own existence as an HIV-positive, BDSM-affiliated homosexual, as if simply by embodying all these things he had unwittingly succeeded in corrupting not just those assembled at the Walker Centre, but the entire adolescent population of America. A North Carolinian Senator, the Republican Jesse Helms, proposed an amendment that would block the NEA from funding art that involved "human mutilation or invasive bodily procedures on human beings dead or alive; or the drawing or letting of blood." "That is his picture," Helms said on July 25th the following year, in a meeting of the Senate, indicating a two-foot-high photograph of Athey tied up, bleeding from the temples, and resembling Saint Sebastian. "[He's] a very handsome man, if you like that kind of man." Whether or

not Helms personally liked this kind of man was left unclear, although when he describes the event at the Walker Centre as "a *homo-sek-shoo-al* film event," he sounds almost as titillated as he does repulsed. That tension — between fearing something unfamiliar, and being afraid that you might like it if you let yourself become familiar with it — characterised the mid-Nineties Republican attitude to any sexuality or sexual act they saw as "deviant" or "sick," which often just meant "queer" or "unrepressed" or "actually hot." Athey, who wrote hilariously in 2015 that he sensed a "silent snap, [a] queen['s] snap" in the pause between "a very handsome man" and "if you like that sort of man" when Helms decried him in the Senate, used the vaudevillian sensibility he had developed in his years as a young preacher for his art less because he wanted to convert nonbelievers than because he wanted nonbelievers to be struck dumb by the force of his desire, and by his determination in the face of all that suffering. If Republican lawmakers and housewives from Minnesota found him frightening to look at, they might have remembered the way angels are described in *Ezekiel 1:5-8* — as having golden, burnished bodies and four faces, hooves and two large pairs of wings, both humanoid and entirely outside all human experience and knowledge — and reminded themselves that things far beyond their comprehension are not only not necessarily evil, but occasionally divine.

In their kinky but informed use of religious symbolism, Ron Athey's performances recall, above all else, something Joan Didion once wrote about the photographic work of Robert Mapplethorpe, with its blend of sadomasochism and homoeroticism and, formally and symbolically, a quasi-Catholic flair. "The tension, even the struggle [in the work is] between light and dark," she said in 1989, in an issue of

Esquire. "There [i]s the exaltation of powerlessness. There [i]s the seductiveness of death, the fantasy of crucifixion. There [i]s, above all, the perilous imposition of order on chaos, of classical form on unthinkable images." Light, in works that rely on self-injury and public violence, tends to win out in two senses — as well as the usual tension between survival and near-annihilation, ensuring that what remains is a sensation of triumph over agony, it should be noted that most practitioners of this kind of art tend to be white. This is perhaps because Caucasian people do not have the same historical relationship with pain as other racial groups — it is easier to be self-indulgently, showily careless with one's body if it is already the specific shade of body favoured by a white supremacist society, rather than one that is more likely to be subject to abuse, injustice and imprisonment by virtue of the colour of its skin. ("We know what happened, and we know who had the whip," as James Baldwin said in his elegant, waspish purr in 1968, in discussion with Dick Gregory. "And it was not *my* grandfather who raped anybody.") There is one outlier who springs to mind: when the artist Pope L. first performed a work called *Crawl* in 1978, dragging himself painfully through the streets of New York in a pin-neat suit and tie, he was playing deliberately with the shock and incongruity of the image, using the juxtaposition of his blackness, his uncomfortable self-abasement, and his crisp attire to provoke. A homeless African-American man crawling painfully on his belly in this context would, he reasoned, barely give New Yorkers pause; what, though, might they think of one who chose to do this of his own volition, dressed as if late for a meeting at a law firm or a hedge fund? "I believed... that the conjunction of a black man and his suit crawling down the Bowery could produce not just contradiction," he informed an interviewer

at *BOMB* magazine in 1996, "but a feeling that would somehow transcend itself." At one point, a black audience member became so enraged at the performance artist's lowering of himself into the gutter that he went to kick him in the face, seeing Pope L. as a traitor for his willingness to place himself in a position that, metaphorically if not literally, black Americans were still trying to escape under the omnipresent tyranny of white bigotry. "He thought I was degrading the image of black people," he recalled. "I wanted to get up when he said that; but then at the same time I thought to myself: Well, that's why you're here, that's why you're doing this — to offer, in a sense, an alternative he maybe doesn't want to see."

Whiteness, with its insulating quality per racial context, sometimes breeds an unwillingness or an inability to see the things that we would rather close our eyes to, the resulting ignorance being as much of a luxury and a privilege as the ability to be casually brutal with our bodies. Early on in his career, Athey had a tattoo of a swastika, which he insisted was intended as an homage to its ancient origins and not to its contemporary incarnation as a symbol for the Nazis. In a 1997 article entitled "Flirting with the Far Right", written for *Honcho*, he explained that he was covering up the symbol after realising that, although he intended it to be "an Indonesian version taken from a textile pattern," the two forms of swastika looked "similar — and both have an impact." He admitted to a half-ironic interest in the intersection between skinhead culture, queer aesthetics, and a kind of sexed-up hypermasculinity that he had found himself "intrigued [by]... some might say obsessed [with]," but also suggested that he'd left this fetish far behind once it occurred to him that the brown, black and otherwise marginalised friends and performers he associated with might not appreciate the joke.

Looking at Ron Athey's writing and his work, it is easy to believe that he was never actually a white supremacist, but it is also an extraordinary privilege to be so white that it is possible to see a tattoo of a swastika and think of Indonesian symbols or of sexy tough-guy cosplay rather to recognise it for exactly what it is: a temper tantrum without finesse that immediately marks the wearer out as either insensitive, or a threat. The "teenage" qualities he believed helped him to perform, unfiltered and un-PC and incapable of fear or hesitation, had outlived their usefulness by the time he became a more established artist, ushering in a different phase in his career that still prioritised the body, but allowed him to develop a new practice more befitting of his status as an elder statesman. As he put it in an interview with *New York Magazine* in 2018: "Grandpa isn't bleeding or sticking things inside his ass for once!"

Referred to as the "Godmother of performance art," the Serbian artist and media figure Marina Abramović would no doubt reject the corresponding, gender-reversed title "elder stateswoman," if only because she is not the kind of woman to enjoy being described as "elder," "old," or even "over forty." Abramović, who by now is as much a celebrity as she is a performance artist, also grew up alienated from her parents, both of whom were "national heroes," she recalls in the 2012 documentary *The Artist Is Present*. "Everything at home was discipline, schedule; I was trained to be like a soldier, literally. I was woken in the middle of the night if my bed was not straight. I never remember my mother kissing me or holding me." In the scene, she is trying to explain exactly how she became the Marina Abramović the art world knows and loves, which is to say how she became the kind of woman who might whip herself, carve a pentagram into her abdomen, perform

great feats of starvation and sleeplessness, allow strangers to menace her with a gun, and collaborate with Lady Gaga. She credits a combination of her parents' distant, disciplinary cruelty and her loving grandmother's religious faith, giving her "a kind of balance between spirituality and that communist discipline" that allowed her to seem simultaneously aloof and terrifying, and desirous of her audience's love. Where Ron Athey's parentage and his early indoctrination into spiritualism led to his performance of self-injury as incontrovertible proof of vitality, sexuality and life, Abramović used similar means to prove her limitless devotion, whether that devotion happened to be to her partner, Ulay, to the art world, or to her devoted fans. There is something constant and unchanging about Marina Abramović: physically, conceptually, and in the sense that her whole practice seems to follow one cohesive thread, with works from 1974 still feeling congruent alongside those made in the 2010s. (This seems obvious, since both religious rituals and military displays are about repetition and precision.) She is still so preternaturally young-looking that, in spite of her love of lasers and dermatological fillers being very, very public knowledge, she was still asked whether she came from a family of vampires in a Reddit AMA in 2012. "I will soon post the photos of my grandmother who was 103 and her mother who was 116," she responded, notably not actually saying "no," "to prove that Montenegro people live long and never age."

If Marina Abramović lives to 116, it seems likely she will keep up the same tireless, military regimen that she does now, making work until she cannot move her body anymore, and dyeing her hair the same flat, tenebrific colour it has been since she was young. To be human — old, infirm, and fallible

— is not an option. "The noblest thing one could do in my family," she said in 2015,

> was to sacrifice everything for a cause. Art became my cause, and it's still everything to me. I dedicate all the energy in my body to my work and have completely sacrificed a more conventional personal life for it... I wake up in the morning with this urge to create; it's almost like I am in a fever. Every single day is structured. I work, work, work, and my curiosity never ends.

Sacrifice, like teeth, can leave a mark. When she returned to her hotel after a particularly gruelling 1974 performance, sometime around 2 am, she has claimed that she surprised herself by looking in the mirror, noticing that a great streak of her black hair had turned spontaneously white. Whether or not this is the truth, it is a neat way to encapsulate what Marina Abramović's work strives to achieve: an absorption, or a channelling, of the extreme emotions of her audience, often in a way that leaves her somehow changed. If she truly is the descendent of Serbian vampires, she herself is a vampire in this mould — a vampire for love and pain. The story makes it easier than one might think to circle back to Johnny Knoxville, who has recently begun doing appearances with bone-white, undyed hair; a man of fifty with the hair of someone twenty-five years older. "To the world he looked like an attractive older-man version of Johnny Knoxville, avatar of eternal youth," a 2021 profile in *GQ* said, alongside photographs of Knoxville dressed in skate-wear. "To himself he looked a little more like... himself." "*Hello*, I started *Jackass 4* a brunette," he grins in a video that accompanies the article, tugging his new argent-

shaded crop, "and now I have silver hair. So, I guess I aged pretty rapidly."

As with Marina Abramović's story, this is more lore than real fact — Knoxville, like his father Big Phil Clapp, had begun turning grey unusually young, the first few streaks appearing shortly before *Jackass* hit the air. Still, it seems reasonable to think that the unusual stress experienced by the stuntman might have had an effect on the changing colour of his hair, and it is not unreasonable, either, to see the connection between Johnny Knoxville's newly-platinum hair and his long history of public injury as allegorical in much the same way as Abramović's Mallen streak. The injuries, as he himself said in that same profile in *GQ*, are a gift he shares with everyone who watches, and they are a gift that alters him in increments as he continues to present them. Certainly, more violent changes have befallen Knoxville's body as a result of his years of bleeding, vicariously, his audience's adrenaline and fear — whiplash, seizures, broken bones, a broken penis that required that he use a catheter for three straight years, a head injury that made it impossible for him to steer his car left without getting dizzy, etc., etc. Still, his choice to finally let his hair grow white after two decades has the air of a reveal, a disavowal of his former image as a perpetual adolescent.

After years of the respective *Jackass* cast members suggesting that they might like to return to doing stunts, the trailer for a new, fourth *Jackass* film was unceremoniously uploaded to YouTube in March 2021. In the clip, the remaining members of the group appear through thick, undulant smoke to the familiar strains of "O, Fortuna!", moving in slow motion in the same way we remember from the opening of 2002's *Jackass: The Movie*. Soon, we notice that although the boys are mostly present and correct, they are no longer boys or even men, but

whatever the male equivalent of "crones" is: old and haggard, faces creased with caked-on silicone and hair concealed with thin, floccose toupees. One by one, the cast is crushed or blown sky-high or pulped to smithereens by something catastrophic, until eventually nobody but Steve-O — who was once an alcoholic and an addict, but has now been sober for over a decade — is onscreen. Steve-O laughs, and laughs, and laughs. On first watch, the trailer is hilarious, designed to bait millennial viewers who are feeling old themselves. On the second, it is moving. The joke at the heart of it is *fuck, we're old* — but it is also, in a register that's quieter and far more bittersweet, *look how much we sacrificed for you, and how it's aged us.*

Because there is, in fact, no male equivalent of a "crone," Marina Abramović's white streak remains mythic, having been concealed — if it existed in the first place — for the sake of her very consistent public image. There *are* ways in which Abramović has aged, however, even if she still looks twenty-five years younger than she is: despite the hellish long-endurance of her sitting, starving piece *The Artist Is Present* in 2010, she now tends to spend more of her time focusing on a direct, zen-like exchange of her energies with her audiences now that she is older, privileging silent contemplation over shock and awe. Childhood looms large in considerations of why a practitioner might choose to actively injure themselves either for art or entertainment because psychologically the choice to do so is so at odds with the adult instinct for self-preservation that it can be tempting to assume that the performer does not have a normally developed human brain at all. Early formative events, as mentioned earlier, tend to shape a person's attitude to pain, to deprivation, and to risk. There is, too, another sense in which the spectre of pre-adult experience hangs over artists like Chris Burden, or performers like the stuntmen who

do *Jackass*, or even over a practitioner like Marina Abramović, who exudes a cool, highbrow detachment but still once made work bloody enough to evoke what Ron Athey called a finessed version of a teenage temper tantrum: like most adolescents, they are motivated by a kind of restlessness, an ability to suspend fear and practicality in favour of expressing anger or extreme dissatisfaction, proving their mettle or protesting their spiritual or societal confinement. They do not so much announce themselves as carve their identities, bloodily and publicly, into their skin, the way a teenager might carve his or her crush's name into a school desk or a tree-trunk; they delight in baffling and nauseating squares, turning the tables on their own alienation so that those too old and tragically unhip to understand why they are doing what they're doing feel as if they are the ones being left behind.

It takes youth, or at the very least a youthful way of thinking, to imagine oneself being so godlike (or at least so unlike anyone else) that death — the most inevitable, unifying force on earth — can be cheated, a sensation that decreases commensurate with our age. In 2006, the year that he turned sixty, Chris Burden wrote that one bright afternoon in California, as he stood on his front path, he had come face-to-face with a juvenile coyote, and that at least momentarily the coyote had appeared to listen to him as he spoke. "I talked to the coyote softly and sweetly," he recalled, "trying to lure it closer to me in the hopes that I might touch it. Like a shy puppy, it listened intently, and through its body posture and slow movement towards me, it appeared to be tempted by my seduction. However, its natural instincts prevailed, and I was unable to touch it." The image — the now-ageing bad boy artist and the adolescent, untamed animal communing at a distance on the edges of the artist's property, the gulf

between them impossible to breach without defying the laws of nature — lodges, like a splinter, in the mind. One wonders whether Burden saw the juvenile coyote and, thinking about its wildness and its danger, then thought of his younger self: the twelve-year-old being operated on without an anaesthetic, the teenager watching footage of a war on television, the twenty-five-year-old student folded into a university locker, the baby-faced kid in the white t-shirt being shot with a .22-calibre rifle in a Santa Ana gallery. Eventually, the coyote turned and fled. If he had looked up what coyotes represented in traditional Californian mythology, Burden might have read that they are trickster gods, sometimes sacred and sometimes malevolent — reckless and cunning enough to have stolen fire from the sun without being burned.

II. THIS PERFORMANCE ART IS FOR THE BIRDS

They are "girls," the title is at pains to point out, and not women — women being your wives, your mothers and your grandmothers, your professional superiors and your high-school teachers, and girls simply being the opposite of boys. Munchie and Ramona Ca$h — two small brunettes — are slim and tanned and button-cute, and they are also taking turns punching each other, very hard, with neat pink boxing gloves while wearing wedding dresses. Clementine, who goes by "Darling Clementine," is also slim and tanned and button-cute, but is a blonde, marking her out as an appropriate referee. (A blonde-on-brunette match, one has to guess, would have too many Betty-versus-Veronica undertones, the cultural war between both factions having raged too fiercely and for too long to require any further stoking.) "Two rules: no shots at the nose, and no shots below the waist," she says — a regulation that is very swiftly scrapped when one girl hits the other girl square in her pretty face, and the first girl retaliates by following suit. Veils, absurd and ghostlike, flap behind their boxing headgear; guitar squalls over the soundtrack. *Rad Girls*, a feminine answer to the eyebrow-singeing, nipple-tweaking cult of *Jackass*, first aired in 2007, its two seasons spanning eighteen episodes and numerous sketches that used periods, thrush, sex work, beauty standards and decontextualized nudity to lampoon the inherent violence — the ridiculousness

and disgustingness and occasional ecstasy — of occupying the conventionally attractive, traditionally gendered body of a (cis, it must be noted) woman. Playing with the boys, the show suggested, may take balls, but playing with the girls takes guts.

As in *Jackass*, the humour in *Rad Girls* tends towards the scatological, the sexual, or the surreal. The absurd names of its skits, read as a list, suggest a fratty, bratty, feminist prose-poem: Wax the Beaver; Smellevator; Wheel of Puke; Fart in Mouth; Stripper Auditions; Crane Wedgies; Turd Batting Cages; Hot Sauce Shots; The Cyst; Nipple Slip News; No Bathroom Break; Pizza Porn; Show Me Your Junk; Preg Strip Party. In a segment titled Yeast Infection News, Clementine conducts political vox pops while pretending to scratch, helplessly and outlandishly, at a vicious yeast infection. "Oh God, this isn't normal," she whines, yanking her hand out of the front of her pencil skirt to reveal tapioca pudding on her fingers. "I sat in a hot tub last night, and I think I might have an infection." It is gross, entirely juvenile, and so unfeminine and graphic that if comedy were boxing, it would probably be outlawed as a shot below the waist. "We have periods, cramps, mood swings and other things that women go through in their lives that [cis] men can't biologically go through, and we mainly work off of that feminine edge," she later remarked in an interview with a student-run alt weekly. "There is a level of intellect to our show that *Jackass* lacks." Whether or not *Jackass* — which riffed on the darker side of masculinity in the same way that *Rad Girls* did on the ugliest, most airheaded and most Cronenbergian aspects of the feminine existence — is lacking in intellectual rigor is, as I would hope is obvious by now, debatable. What is not debatable is the fact that *Jackass*, despite being popular with female viewers, remained staunchly single-sex. "We had a girl on the show from time to time," Johnny Knoxville said

of *Jackass*' all-male rule in an interview in 2010. "She got hurt doing a stunt once and so we decided no more girls doing stunts. Not that they can't — just in *Jackass*, because we all hated feeling that way."

It is funny to hear Knoxville describe *Jackass*' lone female stunt performer as a "girl," too, not a "woman," reinforcing the word's implications in the same way *Rad Girls* sought to clown on them — women might go through experiences that require great pain and suffering, to say nothing of bravery and of endurance, but can the same be said of girls? Stephanie Hodge, who looks a little like a more glamorous version of Ramona from *Rad Girls*, is the babe who was horribly injured on the set of *Jackass*, cracking both her pelvis and her spine after careening down a skiing slope atop a mattress. Fans of *Jackass* may remember her — in a detail that feels so much like a joke about exactly the role one might expect women to play in the world of *Jackass* that it may, in fact, *be* a joke about the role one might expect women to play in the world of *Jackass* — as the nurse who appears in the literally masturbatory sperm bank sketch, or playing a cheerleader, or as the "hot chick" in a repulsively egg-based eating contest. "My parents called me," she recalled, amused. "My brother saw it. Everybody fuckin' saw it. They all said that they wished I would have told them because they all got calls saying, 'Your daughter is puking on TV.'" It is not unusual for female art practitioners to either send up feminine archetypes, or to oppose them, making Hodge's TV debut an accidental precursor to, for instance, the work of the "vomit artist" Millie Brown, who "explores the synergy and separation of mind, body, and spirit" by swallowing coloured milk and then expelling it, orally, onto canvas. "The struggle makes the performance," Brown informed the *Guardian* in 2014. "I think it's very human... it really doesn't

have anything to do with eating disorders. If I was male, [no one would make] such a massive association." Because neither Brown nor Hodge *is* in fact male, it is difficult to escape the usual associations one might make between attractive, slim young girls and vomiting, making the image more piquant. It is unlikely, although not impossible, that the families of the male members of *Jackass* received outraged telephone calls informing them, scandalised, that their beloved sons had been seen puking on the television.

Munchie and Ramona freak out at the prospect of their pretty noses being broken in the bridal boxing skit not only because breaking one's nose is extraordinarily painful, but because to do so as a woman is to risk permanent damage to one's value as a commodity if it can't be fixed. (Imagine, if you will, a female actor with a nose as atypical and askew as Owen Wilson's — then imagine her, as Wilson has, playing a famous catwalk model. It is easier to imagine women being allowed back into the primary cast of *Jackass*, or to picture any one of the primary cast of *Jackass* saying the words "yeast infection".) When the filmmaker, genius, and pig Roman Polanski filmed *Repulsion*, a psychological horror about the torture inherent in being blonde, desirable and female, the cinematographer Gil Taylor famously objected to the treatment of its star, Catherine Deneuve. "I hate doing this to a beautiful woman," he insisted, as if beautiful, suffering women did not make up about eighty percent of the movie industry, to say nothing of Polanski's own filmography. "But then [Deneuve's] beauty is her most immediate and objective character trait," the film writer Greg Cwik pointed out in 2015. "Viewers don't want to see bad things happen to, or because of, a beautiful woman. And yet Polanski and Deneuve play off of the perverse desires of (straight male) viewers." A little over twenty years ago, in

1999, the critic Sally Vincent criticised Deneuve for majoring "in those kinds of Madonna/whore roles that have helped consign women's sex lives to the tiresome exercise of being hauled on and off pedestals by gentlemen who, in any case, needed little encouragement with their emotional aberrations." The main thing she disagreed with when she saw Deneuve play sexy, self-injurious characters, as she did in *Repulsion* or in *Belle De Jour*, was what she perceived as "the cinematic insistence that what we are looking at is... the archetypical woman's authentic depiction of the sadomasochistic parameters of the [typical] female psyche." She believed that Deneuve helped to spread the popular idea, in other words, that women were sufferers *inherently*, self-motivated and perhaps even aroused by the experience: that we, as Picasso once said to his mistress Françoise Gilot, are machines for suffering.

In the 2012 documentary *The Artist Is Present*, Marina Abramović is seen preparing for, then executing, her 2010 performance of the same name: a durational experiment in which the artist sat for eight hours a day in perfect silence, and her audience lined up to sit opposite, one by one, in order to experience what she described as "a piece that destroys the illusion of time." The work, which spanned almost three months, fast became cultish, *à la mode*. "People who sat with her more than 10 times formed their own club," the *Guardian* fawned, "and a group of New York artists gave out badges — 'I cried with Marina Abramović' — to those who had broken down before her." Inevitably and irritatingly, James Franco — an excellent actor and a less-than-stellar artist with an improbable number of degrees — sat with Abramović for maybe sixty seconds, and in doing so briefly succeeded in transforming her performance into The James Franco Show, his absurd, Gucci-model beauty scarcely adequately

camouflaged by his dun-coloured, fogeyish trainers and plaid shirt. ("Marina most powerful is Marina most simple, Marina as Marina," he wrote in a commemorative piece about her for *TIME Magazine*, nonsensically. "I love the simple Marina, the powerful Marina, when the artist is present within her.") More distracting still was a visit from the performance artist Ulay, Abramović's ex-lover and sometime collaborator, with whom she had cut professional and romantic ties in 1988, in what may be the most extraordinary, extroverted break-up gesture in contemporary history — a synchronised walk from opposite ends of the Great Wall of China, culminating in a few dignified tears, a warm embrace, and twenty-two years of mutual radio silence. After they had separated, Abramović began buying designer clothes, and invested in breast implants. "You know, I was 40 years old," she shrugged to the *New York Times* in 2012. "I heard that Ulay made pregnant his 25-year-old translator. I was desperate. I felt fat, ugly and unwanted, and this made a huge difference in my life." Ulay, who died in 2020, aged as ruggedly and naturally as Abramović has unnaturally, augmentedly and smoothly, suggesting that he did not exactly share her desperation. Abramović, now seventy-four, does not look young, but looks impervious to wear: unlined, pale, black-haired, as hard and immovable as a marble statue. "I think I might still love her," Ulay tells the documentary's camera operator, sounding brittle in the way men tend to sound when they have made a terrible mistake. "And I'm okay with this."

In some ways, the scene in which Ulay and Abramović face off at the MoMA, smiling, crying, and then finally agreeing to join hands, is far less interesting than one where Ulay talks about an earlier, similar work the two of them produced together, *Nightsea Crossing*, which "consisted of a man and a woman sitting opposite each other in two chairs, motionless, silent, fasting."

"It was mainly about things that are tremendously disliked in Western society," he continues. "Inactivity — inaction — is discredited. Silence is discredited. And fasting is discredited. So, these are the three things that could obsess people pretty much, especially when you went for [many] days inactive, silent, fasting. Absolutely motionless, which is almost impossible." What makes the scene most memorable is his admission that he gave in before Abramović did, blaming biology in lieu of his own lack of stamina: "A woman," he assures us, "can sit better than a man, because of anatomy." Women are certainly on average more experienced in the art of going hungry than most men, whether or not they also happen to be better built to sit in chairs for longer periods of time — a great deal of the work Ulay and Abramović have made together is, in fact, reliant on the different ways that men and women fuck and socialise, coalescing into a kind of hermeneutics of heterosexuality. Perhaps their best known and most reproduced work, *Rest Energy*, sees the two artists held in perfect balance by a bow and arrow, the bow primed in Ulay's fingers, and the point of the arrow squarely aimed at Abramović's beating heart. "It was really a performance about complete and total trust," she later said, somewhat underestimating the degree to which it was about her powerlessness at the hands of her male lover, to say nothing of how much less resonant it would have been if the two genders were reversed. *Rest Energy* is about heterosexual sex and relationship dynamics as much as it is about the bond of trust, in the same way that 1976's *Relations in Space* — in which they ran, nude, at each other's bodies blindly until both were bruised and aching — literalised, almost comically, the supposed "battle of the sexes." When they called this series, made between 1976 and 1979 when they were both in love, *Relation Works*, Ulay and Abramović meant for the "ship" to

be implied; when their relationship *did* work, it still adhered to more or less the same outdated, gendered rules as every other heterosexual couple's, the bow controlling the arrow staying taut but also never changing hands.

Somewhat improbably, a work by Marina Abramović entitled *The House with the Ocean View* was parodied in HBO's pro-consumerist, heteronormative fantasia *Sex and the City*, in an episode in which its journo-heroine, Carrie Bradshaw, visits a Chelsea gallery and sees a black-haired, white-clad artist undertaking a performance in which she is trapped up on a mezzanine by ladders lined with knives. "There are depressed women all over the city doing the exactly same thing," Carrie informs a Russian conceptual artist played by Mikhael Baryshnikov, rolling her eyes, "and not calling it art. Put a phone up on that platform and it's just a typical Friday night waiting for some guy to call." "You are comic?" Baryshnikov's artist asks her, smirking slightly, as if he cannot believe that she is meant to be a writer. Still, as far as commentaries on Ulay and Marina Abramović's sexual and professional history are concerned, Carrie's comparison is not without some merit. This may be the greatest difference between women who orchestrate deliberately injurious works of performance art or entertainment, and the men who do the same: women's self-harm, playing as it does into a masochistic history with the opposite sex, cannot help but be seen in relation to men. Men, who sometimes contest the idea that it is hard to be a woman by suggesting that, traditionally, it has been men who go to war, hurt themselves to prove their mettle, or to entertain their peers. If *Jackass*' violence can be read as a shamanic disengagement from the trauma experienced by the US in the wake of 9/11, and Chris Burden's as a poetic reaction to the war in Vietnam, work by artists like Abramović or Gina

Payne might be interpreted as being an exorcism of *the feminine itself*, a self-lacerating admission of the same terrible feeling of inherent victimhood so scorned by Sally Vincent. For once, these were not beautiful women having things done to them by "gentlemen who, in any case, needed little encouragement with their emotional aberrations," but beautiful women electing to do the harm with their own exquisite hands, a fucked-up show of independence: *Ms Abramović said she would slice the flesh herself.*

"Why has no mother, including Hamlet's own, admitted to her own libidinous impulses," asks Hilton Als, in the opening essay of his 2013 collection *White Girls*:

> Saying this crazy-ass dick or uncontrollable freak works for me, I could never do what he does in the world, be so out of control, terrible and boundary-less, I'm a woman, confined by my sex, prohibited from acting out because other lives, my children's lives, depend on me, but there's my husband acting out for me, what a thrill as he crashes against the cage of my propriety.

The first time Marina Abramović met Ulay, she had carved a bloody pentagram into her abdomen for a performance at a gallery in Amsterdam, and although Ulay said that, when he'd seen her earlier, he had said "wow," the sight of her using a razorblade to cut into her body sickened him. "I thought 'no, no, maybe not,'" he recalls, wincing almost imperceptibly, in *The Artist Is Present.* "After that," he adds, "I started nursing her wounds. I didn't lick her wounds, but I cleaned them." Given the dynamic of their partnership once they began to work together, his concern seemed to have less to do with the idea of his beloved being injured than with the idea of her injury being entirely self-sustained, without the need for an

uncontrollable freak to set her free. In a work like *The House with the Ocean View*, made long after the dissolution of their bond, Marina Abramović does not necessarily crash against her cage so much as she demonstrates an unerring, unsettling ability to enforce and endure her own imprisonment. "The idea of the work was experiment. If I purify myself without eating for 12 days, any kind of food, just drinking pure water, and being in the present moment, here and now, in the three units on the wall, which represent my house, like bathroom, the living room and sleeping room, where the ladder[s] coming down to the space are made from the knives, so you never can leave," she told the MoMA. "That kind of rigorous way of living and purification would do something to change the environment and to change the attitude of people coming to see me." The audience's energy — sometimes adoring, sometimes hostile — informs the eventual outcome of her work, deciding whether or not her extreme rituals scan as spiritually enriching, or degrading. In 1974, in *Rhythm 0*, she spent six hours standing still, permitting viewers to use objects she'd provided on her body in whichever way they chose. Abramović was twenty-eight that year, dark and lovely and possessed of what her friends often described as a mysterious, almost thaumaturgic power over men in general; in images of the piece, she has the serious, ascetic air of a penitent or a saint. The items given to participants included nails, scissors, a scalpel, and a handgun that contained a single bullet. "In the third hour," the art critic Thomas McEvilley recalls, "all her clothes were cut from her with razor blades," and then:

In the fourth hour the same blades began to explore her skin. Her throat was slashed so someone could suck her blood. Various minor sexual assaults were carried out

on her body. She was so committed to the piece that she would not have resisted rape or murder. Faced with her abdication of will, with its implied collapse of human psychology, a protective group began to define itself in the audience. When a loaded gun was thrust to Marina's head and her own finger was being worked around the trigger, a fight broke out between the audience factions.

This outbreak was, of course, exactly what Abramović had hoped for, having guessed that offering up her woman's body to a crowd would end in atavistic violence. In the novel *In the Cut*, a sickening and brilliant erotic thriller by the writer Susanne Moore, an English teacher with a passionate love of language and of sex named Frannie Avery is informed that the serial killer operating in her neighbourhood often keeps "trophies" from the women he dismembers. "Yes," she thinks. "I know that. The difference between male and female perversion [is that] the action of the man is directed toward a symbol, not himself. The woman acts against herself." (Frannie, who starts sleeping with the cop who tells her this, is not entirely certain he isn't the murderer himself, helping her to make her point: it is she who will be killed by her perversions if her hunch about her lover is correct, her willingness to accept the possibility being indicative of that same feminine desire to turn the violence inwards.) Marina Abramović, in *Rhythm 0* and as a practitioner in general, is both self *and* symbol, a flesh-and-blood woman and a representative of womankind inviting pain and retribution. As in Yoko Ono's *Cut Piece*, a similar work from 1964 in which the artist allowed viewers to slice the clothing from her prostrate body, a simmering, frightening tension results from the inevitable collision between a determinedly submissive woman and a stranger with an object

that might be used as a weapon. Ono, who provided simple and dispassionate instructions for participants — "members of the audience may come on stage — one at a time — to cut a small piece of the performer's clothing to take with them. Performer remains motionless throughout the piece" — saw the result as "a poem," each swift, invasive movement an addition to the verse. Abramović, amplifying the possibility of violence by offering up a gun, was less interested in poetry than in a kind of bodily form of essay-writing on the subject of repression, sexual violence, and suggestibility. Her upbringing as a military brat ensured that she was built for combat, an ideal participant for any war that might erupt between two factions, whether those two factions happened to be a performance artist and her audience, or women and men.

In *The Artist Is Present*, Abramović appears dazzled by two things: her late coronation into art-world megastardom, which has made her the only performance artist with a public profile almost equal to that of the very famous people she routinely ropes into collaborations, and her own insatiable desire to keep increasing her exposure to discomfort. Running parallel with her love of glossy press and plastic surgery and hip, monochromatic Yohji clothes is what she sees as a steadily escalating need to put herself through hell, as if one increasing passion had to cancel out the other. The effect Abramović has on the men around her remains supernatural, undimmed by time or age. "You're totally being seduced," Jeff Dupre, the co-director of *The Artist Is Present*, told *The Cut* in 2016. "You're being processed. Of course, it's incredibly fun, you feel like you're the centre of the universe." "Marina seduces everybody she ever meets," the curator and MoMA director Klaus Biesenbach — with whom Abramović once

had what he has called a "more than friends" relationship — says in the documentary. "I try to be matter-of-fact with her, because I don't want her performance persona to get in the way. Because with Marina, she is never not performing." It is funny to hear Biesenbach describe, cautiously and maybe even fearfully, her power to inflame an audience's desire, as if sex appeal were more or less equivalent to the gun in *Rhythm 0*, or the arrow in *Rest Energy* — a thing that could go off or be set loose and tear a heart to pieces unless whoever is wielding it is suitably placated and at peace. For Abramović, seduction is another long, endurance-based kind of performance, as challenging in its delicate alembic of intensity and apparent inertia as her sit-ins or starvations, and thus equally as vital to her practice. An armchair psychologist might say that she felt moved in some way to discipline or to punish herself for the sin of wanting to be wanted, and of continuing to shape herself into the firm-breasted and ageless kind of woman she felt Ulay might have desired when he left her in order to impregnate his young translator — not necessarily privileging her looks over her brains, but certainly allowing both things equal weight. "I have no idea why I have to make things harder and harder," Abramović murmurs in the documentary, gazing disconsolately at the emergency commode that has been built into her chair in order to allow her to sit silently for eight hours at a time. "But this is my cross to carry. This is insane."

"I've often thought of a female Christ," Eileen Myles writes, in the novel *Cool for You*. They conclude that such a thing could never happen, citing "people's feelings about the delicacy of women," and the fact that they see female suffering as a "meaningless display." "If you belittle us in school," they add, "treat us like slaves at home... what would be the point in seeing [a woman] half nude and nailed up? Where's

the contradiction?" In 1969, the Danish artist Lene Adler Peterson walked through the Stock Exchange in Copenhagen, naked, with a crucifix, for a piece most commonly referred to as *The Female Christ*. The title, a tautology for the same reasons Myles suggests, is itself a provocation. (Coverage of the event from the Danish paper *Politiken* takes great pains to note that Peterson is "beautiful.") If it is rare for us to see a female Christ, it is not rare for women to self-sacrifice in order to achieve what they perceive as greatness, and history has seen many female martyrs: Wilgefortis of Portugal, who prayed that God would make her ugly, starved herself until she grew hair all over her body, eventually — almost like a female Christ — ending up crucified; Catherine of Siena, who died at the age of thirty-three — again, like Christ — ate nothing but the Eucharist for the last few years of her life, and forced herself to vomit almost daily. God, most often pictured as a man, created not just one or two lives, but all life, making the most generative force in written history de facto male. If the Bible is to be believed, he did so swiftly, not in nine months but in six clean, fleeting days. Women do it bloodily, agonisingly, screaming out. "Girls don't make good monsters," Chris Kraus writes in *Aliens and Anorexia*. They may not make messiahs, either. What they do make is good martyrs and ascetics, ensuring that Marina Abramović's offering of a loaded gun to her assembled congregation — in stark contrast to Chris Burden's willingness to be shot in the arm *mano a mano* — feels distinctly feminine in its embrace of possible annihilation as a demiurgic force. "Only a woman could use those destructive contraptions that man has imagined for a constructive end," the artist Niki De Saint Phalle once said, about the use of guns by women artists, "and that's beautiful."

In the novel *Acts of Desperation* by the Irish author Megan

Nolan, an unnamed young woman falls in love with a cruel, wolfish-looking art critic, and enters into a relationship that bears out the dynamic Frannie Avery outlines in *In the Cut*: unbalanced, dangerous for the woman, sexually sustained by a pervasive threat of either psychic or literal violence. The unnamed narrator — who is intelligent, impetuous, self-destructive and occasionally a little arrogant, not unlike Frannie — tells us several times that she sees love as a sustaining form of near-religious faith, a cleansing fire through which meaning is conferred by suffering. Because she thinks of her bad boyfriend as a god, she believes he is omniscient, always right, even when he is moving in particularly mysterious ways. Still, cracks do show: one night, he encourages her to watch some footage of the Chris Burden performance *TV Hijack*, in which Burden appears on live television and holds up his interviewer with a knife. That interviewer, Phyllis Lutjeans, is surprised and then alarmed when Burden, switching suddenly from a fine artist into a potential terrorist, puts a blade against her throat and threatens her — physically, sexually, ultimately fictionally, although how much it had felt like fiction for her in that moment remains questionable. Nolan's heroine is sickened by the idea that the art world has accepted what is in effect a televised assault as something inherently meaningful, too daring and too brilliant to be condemned. (Her boyfriend, by exposing her to *TV Hijack* and behaving as if he is administering a test, is mirroring the artist's own propensity for forcing sudden, provocative ethical conundrums on his audience: "If Burden's performances required his submission to bodily and mental stresses," Anne M. Wagner wrote in *Artforum* in 2011, "the viewer, too, had tests to undergo. Ought one simply to accept an artist's decision to be shot, and then

watch quietly while the gun is loaded and fired?") "Reading about [Lutjeans] afterwards," she says,

> I found interviews in which she confirmed she was not complicit, was shocked and frightened, but defended the piece — it was simply Burden's style... What would you choose? Either you can be famous for being a shrill prop in a great man's work, a victim sacrificed to the gods of art, or you can nod along and applaud. You can have a seat at the big boys' table for being such a good sport. So go ahead: ha ha ha.

Is it possible to earn one's own seat at the big boys' table, as a woman, not by laughing along at your degradation, but adopting all that gung-ho, big-boy violence for oneself? Culturally, there is something shocking in the image of a woman choosing to destroy what is supposedly — which is to say, misogynistically — her most valuable asset: her own flesh. If seeing the inside of a good-looking blonde woman on the internet no longer holds much shock value, it is arguable that some shock remains when that inside is the inside of her left arm. Paige Ginn, a sunny, pretty, leggy girl from San Diego, has achieved renown online for faking violent falls in very public places — at In 'n' Out and at the mall, at Walmart or the bowling alley — in a way that alarms and delights her fans in equal measure. On May 26th, 2016, she shared a photograph on Instagram of the skin stripped from her forearm by a tree-branch, the interior of her body flashing crimson. "Bush: 9,273,280 Paige: 0," she wrote in the caption, perhaps more casually than one might expect given the severity of the injury, adding: "#Timeforlifeinsurance." As with Johnny Knoxville, Ginn's obvious attractiveness is intended to add seasoning to

the joke; both of them are toned and tanned and enviable opposite sides of the same hot coin. In a clip where Ginn falls helplessly inside a laundromat, her perfect legs fly out akimbo like a Barbie being used nefariously by a perverted, precocious five-year-old; on the beach, she flings herself out of a boat and onto land in booty shorts so minute that the end result resembles a cross between a Crossfit ad, a skit performed by Buster Keaton, and a pornographic take on Hans Christian Andersson's *The Little Mermaid*. In the In 'n' Out-set clip, she coordinates her outfit and her wig to the ketchup-and-mustard colours of the outlet's famous logo, making herself an eye-catching logo, too — a capitalist symbol and a piece of living pop art, maybe unwittingly drawing parallels between the casual consumption of white girls who might have been Sorority sisters, and the casual consumption of fast food.

The *Jackass* boys' suggestion that no chicks ought to be harmed in the making of their TV shows and movies seems far quainter after watching Paige Ginn's videos than it did when *Rad Girls* aired — obviously, it is clear in 2021 that women should be doing whatever they feel like doing with their bodies, whether what they feel like doing is dieting or getting fat, having children or remaining staunchly childless, getting plastic surgery or getting fit or getting borderline-concussed as a result of hurling themselves headlong into ten or fifteen storage boxes in a Walmart. There is something more punk, though — more possessed of a real, lusorious air of violence, and accordingly more dangerous and free — about Ginn's stunts in particular than there was about the costumed, scripted MTV skits orchestrated by the *Rad Girls*. Here, one thinks, watching her videos on YouTube, is a woman who would probably agree with Hunter S. Thompson's assertion, in the voicemail that he left for Johnny Knoxville, that the

words "violence" and "fun" can be synonymous, the rush of being hurt but not being irreparably damaged something like the rush of drugs, or sex, or love. Nothing by the *Rad Girls* ever feels as pointless, and accordingly as giddy, as a compilation of Ginn's "best falls" from 2013-2018, a five-year project with no aim, no purpose, no narrative and no obvious financial gain for its creator. America loves a tomboy who still looks like a Victoria's Secret model, an Olivia Munn or a circa-1967 Goldie Hawn, but there are limits — it is considered bad form to break or scar the merchandise. *Vice* magazine, a cultural touchstone Ginn might be a little too young to be familiar with, once ran a photograph in what it used to call its "Dos and Don'ts" of a beautiful young woman at a party, passed out after drinking one too many beers. "When women get all *Weekend at Bernie*'s," the male caption-writer groaned, "it's just not right. It's like she fell asleep at the vagina, and that makes all mother's sons feel uncomfortable." The writer's fear being for the woman's hypothetical unborn son and not her safety, picturing her as the designated driver of her reproductive system and not as an actual person, is not terribly surprising when one considers the caption's provenance: it will have been either edited or authored by the right-wing talking head Gavin McInnes, who progressed from being a co-founder of *Vice* to being the founder of the Proud Boys. Still, it perfectly encapsulates an irritatingly pervasive attitude towards the bodies of desirable young women, whose fertility and reproductive history are considered to be matters of general public interest. Ginn, to expand on the embarrassing, sexist *Vice* analogy, is not so much asleep behind her body's wheel as she is steering it with the insane abandon of a seasoned rally driver, open-eyed and screaming, joyriding, crashing into

barriers in order to experience the sick, effulgent pleasure of brushing up against death.

Just as adroit at upending sexual and social stereotypes is a mysterious one-minute clip added to YouTube in 2016, with the eloquently self-explanatory title *British lads hit each other with chair*. Four boys, aged somewhere between seventeen and twenty-three, are standing in the concrete backyard of a typical suburban home somewhere in Britain, quivering with the nervous energy of thoroughbreds before a race. One is shirtless, and another is in nothing but a pair of jogging shorts; both are fit, but in the manner of a labourer or a builder rather than a gym-rat, softened slightly by what one has to imagine is a steady flow of booze. The boy without a shirt goes first, having to swig wine from a bottle and then dash it, showily and dumbly, on the ground to build his courage; the boy wearing only shorts, moving with the eager fluidity of a Looney Tunes cartoon, lifts a folding garden chair above his head. What follows — the first boy being clobbered until he is on the ground, a third boy sweeping in to take a beating, the first boy returning determinedly to starting position and then being beaten until he is on the ground *again* — would be considered unremarkable in the pantheon of copycat *Jackass* stunts if it were not for the pervasive, intense air of homoeroticism colouring the entire chaotic stunt, in particular the video's first seconds: before the ensuing violence, the two nearly-naked men lean in and, as if this were something they did frequently, exchange a soft, delicate kiss. It is a kiss as casual and honourable as a handshake, an assurance from the one man to the other that whatever may transpire, he will not come to irreparable harm — letting lips do what hands do, both participants appear to make a contract. Later in the video, when the first boy is on the ground after the second

round of pain, the other keeps the promise made by that earlier kiss by cradling him, Pieta-like, the two men touching skin to skin. The willing victim seems to have experienced a transformative agony, his breathlessness and wide eyes closer to an erotic expression than a hurt one. "That's ridiculous," he repeats, twice, before another male voice somewhere off-screen offers an amazed-sounding corrective: "That's fantastic."

To read an intentional statement about gender roles into the porny, atheistic passion play of *British lads hit each other with chair* is more or less as ludicrous as doing so with one of Paige Ginn's compilations of her various falls. Still, art can be an accident, and it is undeniable that both of these artefacts — especially paired — express a truth about the use of injury and agony as a conduit for escaping, or at least gratuitously fucking with, the gender binary. A body in immense pain can feel genderless, its status as a site of hurt more meaningful in the white-hot and blinding torrent of sensation brought on by a punch or kick or cut than its official designation as a body that is sexed. (It is worth noting, for example, that receiving a swift, killer kick directly to the testicles is a de facto male injury only if you believe — which I personally do not — that only men have testicles that can be kicked.) The artist Nina Arsenault, a trans woman whose more-perfect-than-perfect silhouette is so curvaceous that Mattel once asked her to play Barbie at a party at Toronto Fashion Week, has to date undergone sixty painful surgeries to change her body and her face, an experience that she describes as a dead-split of "ecstasy and suffering." Her post-surgery self-portraits, in which she is bloodied, bandaged, and as luscious as a porn star, capture something of that blend of agony and spiritual ascendance. In another photograph, from the 2012 performance piece *40*

Days and 40 Nights: Working Towards a Spiritual Experience, she is seen whipping her own alabaster back before a mirror, the pale dome of her shaved head and the curved outline of her breast in conversation with each other as if each were arguing opposing sides on the same case. "My artwork explores culturally constructed ideas of maleness and femaleness, realness and fakeness. Most of all, I explore my body as an object," she suggests, in a talk for Ideacity at which the cis, middle-aged male compere introduces her as "a performer of femininity, in the sense that there is a lot of drama and theatre involved."

"My ideas about objectifying myself," she later says,

are not even my ideas, and they're not even new ideas. They are everywhere in culture. [For the work of being Nina Arsenault] I've objectified myself in numerous ways. I have had cosmetic surgery, where I have taken the idea that I have a soul, and then I've put that on a shelf for a while and looked at my body in terms of line, form, mass and structure. And I also have an inanimate substance inside my body — silicon — so literally, there are parts of me that are inanimate, and yet they're me.

The compere is right, she says, in suggesting that there tends to be "a lot of drama and theatre involved" in being a woman, so that Arsenault's transition into something *more than* — ultra-sexual, hugely buxom, her teal eyes and pillowy, heart-shaped mouth conspiring with her unreal figure to suggest either a femmebot or a souped-up mannequin of Paris Hilton — is not meant to be read as the natural outcome of a gender reassignment, but as three-dimensional, conceptual commentary on the nature of the feminine itself. "'Realness'

was not the aim," the artist and writer Morgan M. Page said of Arsenault in 2021, in a piece that offered a corrective to a Twitter hoax about her death. "Nina longed to touch God Herself through the knife." That the two women Arsenault has impersonated in performance works — namely Barbie, and the most famously fuckable cartoon in movie history, Jessica Rabbit — are not technically "real" women only adds weight to her thesis, her insistence that this kind of "ideal" body type is "attainable, but only through suffering, and only for a time."

The deliberate, heightened falseness of her femininity also allows her the advantage of being able to remove it or decrease it for effect, as if she had placed a woman costume on top of her woman's skin. For *40 Days and 40 Nights: Working Towards a Spiritual Experience*, Arsenault rented out an empty shop space in Toronto and spent eight hours a day for eleven days engaged in ritual self-harm, meditating, and cycling naked on an exercise bike to the sound of what one critic called "diva-styled doses of grand opera." In preparation, she had undergone a surgical procedure without general anaesthetic in a Guadalajara clinic, mentally recording every cool incision of the knife into her flesh; she had spent twenty-nine days eschewing sex and, on and off, both food and sleep. In the space, she routinely whipped herself, mostly keeping a straight face but sometimes crying out in pain, the extraordinary pallor of her skin a perfect canvas for red welts. Barefaced and seen without her customary pin-up's wig, her large, firm breasts appearing bolted to her waiflike body, Arsenault resembled nothing so much as a piece by the queer sculptor Cajsa von Zeipel, whose Amazonian women combine elements of the masculine and the feminine in such a way as to rebuke sculptural tradition, making what was

"classical" look suddenly outdated and embarrassing. Zeipel's figures, sculpted to a minimum of seven feet, are designed to overshadow and intimidate the viewer, blowing up what was once pretty and alluring into something that is less explicable, as close to monstrous as to hot. "The approach to classical sculpture has always been to reduce the scale and form of women," Zeipel informed an interviewer in 2012. "The female form is [typically] scaled down and the male structure is [typically] exaggerated. No more of that, please!"

Nina Arsenault, throughout her twenty-year career, has done nothing to reduce her scale or form, preferring to expand, at once, the outer limits of her body and the confines of her gender. Much like Marina Abramović, she works to exorcise some of the physical and mental pain visited on her as a result of her experience of living as a woman, her frustration at being punished by conservatives and feminists alike for not conforming to their standards. Her adoption of, and subsequent dismantling of, hyper-feminine attributes might be interpreted as a generous act of martyrdom for trans and cis women alike, the former often unfairly yoked to a conventional image of femininity as a matter of life and death as well as of conformity, desirability, and professional advancement. In a lecture at the ICA in 1973, the artist Agnes Martin spoke about the terror and uncertainty that came with wanting to be perfect, and although technically Martin was referring to her work, that same pressure might be said to be exerted by the need to correctly project the right image of womanhood into the wider world. (For Arsenault, of course, work and the act of being a woman are inseparable in every sense, mutually sustaining and creative.) "The panic of complete helplessness," she suggested, "drives us to fantastic extremes." In a work called *The Silicone Diaries*, Arsenault delivers an

unflinching monologue about her self-actualisation, not self-pitying or ghoulish but explicit all the same. "Forehead twice, jaw twice, nose five times, cheeks twice, lips three times," she drones, crawling catlike on the stage in front of an enormous, stomach-churning video projection of the footage from her various plastic surgery procedures, her semi-transparent vinyl gown making her move like someone tangled up in bondage. Her argument is that, although narratives about trans women tend to focus on the torturous period prior to transition, society ought to see the transformative work itself as something at once agonising and constructive, a heroine's journey characterised by pain and sacrifice. In other words: her suffering is singular and meaningful, but it is singular and meaningful in the same mode as many other women's suffering, all of which has less to do with what was earlier described by Sally Vincent as "the [supposedly] sadomasochistic parameters of the female psyche" than it does with an incredible and nearly superhuman inner strength, a deep desire to adapt and to survive. "Yes, I am different [from cis women]," she acknowledges, "but everybody's lives are mythic, everybody's lives are big. It's a lie of TV, capitalism, propaganda, that our lives are casual — that if we could see inside the homes of families, their lives would be like a sitcom."

In the *Jackass* family, whose image and continuing narrative on television certainly has mythic qualities, pain is also valorised, and the ability to bear it is presented as a marker of both masculinity and honour. The show's cast, united through their trial-by-fire approach to violence, are marked out as "different" by what Steve-O has described as the projection of "a false impression that we [a]re invincible somehow." (The warning that precedes each show that viewers should not attempt to replicate the stunts in their own homes, writes

Uncas Blythe, serves to indicate "a priestly marking off of sacred space," proving that "this [is] most High Tomfoolery.") So appealing is the myth of their survival in the face of all that bloodletting and bruising that a number of male American teens — a group already defined by their unwillingness to believe that they will ever age or die — began to film their own homages, full of roundhouse kicks and swift blows to the head and bright, agonised screams. One *Jackass* stunt in particular, The Human Barbecue, was swiftly banned from re-runs after it inspired a terrible and almost fatal incident in Torrington, Connecticut, in 2001. As one might imagine from the name, the skit revolves around a man-sized barbeque that has been built in what appears to be a suburban backyard, not unlike one that might be found in Torrington, Connecticut. Johnny Knoxville, who is on particularly extroverted form, is the human of the title, marinating himself naked in a kiddie pool of steak and liquor and then slipping on a flame-retardant suit; the meat, having been satisfactorily seasoned with a heady combination of Jack Daniels and male sweat, is tied liberally to his costume, and then Knoxville lies down meekly on the grill and slowly turns, the flames occasionally jumping to his face as he pretends not to be nervous. "Hey," he yells, his voice wavering with what might be genuine terror but might just as equally be terrible pain, "is my ass burning?"

The incident in Torrington, Connecticut, played out on a January evening, after dark and on a night that one imagines might have been a little less than temperate. A boy named Jason Lind, who had invited several friends over to hang out on a Friday, had reportedly been experimenting with dangerous stunts for several weeks, setting fire to his own boots and then jumping into snowdrifts to avoid having his feet engulfed in flames. Lind was thirteen, and enjoyed skateboarding

and doing dangerous tricks on BMXs, which presumably explained why he saw the arrested, reckless thirty-year-old perma-teenagers of *Jackass* as his peers — if they were older, bigger, richer and more famous, they were also representatives for an alienated, nihilistic swathe of American boys like Jason, who believed in violence as a badge of masculinity, a rite of passage into life as an American adult man. "Around 10 p.m.," the *New York Times* reported,

> Jason and a 14-year-old boy described by the police as a close friend went into the backyard, officials said. Jason was wearing old clothes and a motorcycle helmet when he let his friend douse his pants and shoes with gasoline and use a match to set him on fire, the police said. The teenagers in the house called 911. By the time the fire was extinguished, Jason had been burned on his legs and hands.

Just days after the incident with Lind, a twelve-year-old in Florida set fire to his hand and ended up with severe burns, a stunt involving bug spray he'd conceived of as a tribute to the cast of *Jackass*. "I don't blame myself," he later said. "I kind of blame the show." By the spring, MTV had brought an OSHA representative onto the set of season three, whose checks and balances extended to insisting that when cast member Dave England ate a "vomelette" — made by swallowing the various ingredients of a mixed-vegetable omelette, and then vomiting them up — it had been heated to an FDA-approved "safe temperature" of 144 degrees.

The difference between *Jackass* and their fans, once less than clear, became immediately obvious in the wake of these new strictures: though the show was rough-and-ready, and

although it had the air of being made haphazardly by men with teenage boy mentalities and lean, elastic bodies that bounced back without a hitch, it was a burlesque, not an actual test of manhood so much as a humorous and abstracted bit of theatre about being a heterosexual adult man in circa-2001 America. Like Arsenault being described as "a performer of femininity," the *Jackass* players are performers of a classic rough-and-tumble brand of maleness, and as in the case of Arsenault, the performative quality of their relationship with gender sometimes means intentionally fucking with "culturally constructed ideas of maleness and femaleness, realness and fakeness."

In a paper called "This Performance Art Is for the Birds: Jackass, Extreme Sports, and the De(con)struction of Gender," Robert W. Sweeny notes that, "after rising from the grill, Knoxville samples a piece of barbequed meat, and states, wearily: 'This performance art is for the birds.'" Sweeny records this because of the obvious double-entendre of the saying "for the birds," which colloquially means something like "worthless, not to be taken entirely seriously," and which might also — if we read "birds" as a slang word — be interpreted as a suggestion that performance art is the domain of women, and not the domain of men. When Knoxville appears naked, lounging in that kiddie pool and being drenched with bottles of Jim Beam, crying out that he finally understands exactly how his liver feels, it does not seem entirely inaccurate to say that the sketch feels like something "for the birds" in a third sense — its hillbilly eroticism is too flagrant to be accidental, self-objectifying enough that it is impossible to imagine he is not in on the joke. There is, too, a fourth interpretation of the phrase, albeit one that requires limbering for a stretch: if the bawdier sketches that appeared on *Jackass* often veered into

convivial homoeroticism, Knoxville's flaunting of his body in The Human Barbecue feels like a different kind of queering altogether. One might argue — if one happened to be open to wild leaps of critical logic, favouring spirited interpretations over sane ones — that the scene not only challenges his masculinity, but *feminises* him, his passivity and nudity and coy deportment all reminding us that usually, it is women who are naked, coy, and passive in TV shows and the movies. "Johnny Knoxville," as the novelist Mikaella Clements put it in 2021, "is still the absolute encapsulation of gender envy for me… *Jackass* [is] dyke camp."

"It seems that the appetite for pictures showing bodies in pain is as keen, almost, as the desire for ones that show bodies naked," Susan Sontag wrote in 2003's *Regarding the Pain of Others*. If pain and naked bodies both appeal to audiences looking to be titillated, it makes sense that an exotic combination of the two would count for double, quickening the blood. Sadomasochism as performed by straight, cis men and women, the critic Sarah Nicole Prickett once argued in an essay for *Artforum*, is "a campy, mirthless drama based on heterosexuality," a description that with minor alterations might apply to certain works of body-based performance art. (If Marina Abramović's works with Ulay cannot be categorised as dramas based on heterosexuality, it is unclear how else they ought to be described.) The difference between men's and women's self-injurious art or entertainment does not fall exactly along clichéd hetero-centric gender lines, but it skirts close — when men do hurt themselves, it tends to be in order to create a show of strength, and when women do, it tends to be either expressing a resistance to oppression, or embodying it physically in such a way as to unnerve or fuck with those watching them. As in sadomasochism, this specific

brand of being hurt does not necessarily connote a loss of power, consent being the most empowering factor vis-à-vis what one does or does not subject one's body to, and as with sadomasochism audiences are inclined to associate "deviant" acts like this with sex even when they are not especially or explicitly sexual in nature. This last point, like most instances of sexualisation in contemporary culture, counts doubly if the artist happens to be female. Performance qua performance, for a woman, the artist Carolee Schneemann said in 2015,

> has these connections with cultural pleasure for a male audience. It's the tradition of the dancer, the striptease, the beautiful actress. Male performance, by contrast, is usually highly masculinised. It's challenging the body in a very physical way. It's climbing a mountain instead of laying on a glacier in your underwear.

It is interesting, though not surprising, to note that, like dancers, strippers, actresses and people generally willing to be seen lying around in public places in their underwear, glacier or no glacier, most notable female performance artists who work naked tend to be both hot and thin.

In writing about binary gender with regards to self-injurious bodily art, it is easy to primarily cite women, and not men, with men being the phallic yardstick by which all others are measured in both art and general life. Being gendered, it would seem, is "for the birds." (See also: the divide in galleries and media between POC artists and just plain artists, with the latter category usually encompassing white men and certain notable white women.) "To leave masculinity unstudied, to proceed as if it were somehow not a form of gender," the academic Calvin Thomas argues, "is to leave it naturalised, and thus to

render it less permeable to change." It is curious to think that *Jackass*, with its knowing winks about the performativeness of heterosexual male bonding, is helping to course-correct this unfortunate impermeability by offering up as neat a study of the falsely masculine as Marina Abramović and Ulay do of straight relationships, or as Nina Arsenault does of the agony of being femme. The most interesting way to use self-injury as a way to explore one's gender is to act in opposition to what might otherwise be expected of you — to be a beautiful sorority girl who plays the stuntman, or a stuntman who displays himself like a beautiful sorority girl, or a trans woman who not only shares her transition with her audience, but makes it obvious that her ordeal was not pitiable or ugly, but heroic. One more curious thing: after reading Sweeny's paper, I ended up watching the now-censored Human Barbeque sketch on a *Jackass* fan channel on YouTube, wanting to hear Johnny Knoxville say the line about performance art and birds with my own ears. In this version, he does not say "this performance art is for the birds" at all, but simply winces and then offers some advice, germane regardless of the gender of the viewer: "Don't try this at home."

III. I WAS MAD AT THE TIME, OR I NEVER WOULD HAVE DONE THE THING

"I wanted to write the Great American Novel," the Ritalin kid informs the talk-show host, the camera lingering on his twitching Converse sneakers. "Or I wanted to write a novel. Either way, I wanted it to be American." The filmmaker and artist Harmony Korine, who is in this moment twenty-five years old, is on *Letterman* promoting his new book, *A Crack-Up at the Race Riots*, which is less a novel than it is a demonstration of what boys like Harmony Korine could get away with if they happened to be famous in the Nineties. This is Korine's third time around on the show, after which he will earn a lifetime ban from *Letterman* for being caught trying to steal from Meryl Streep while in the green room. In his earlier appearances, he had the look of a boy dressed up in his older brother's suit for Sunday school, as if somebody shrank him down by ten or fifteen percent with a cartoon ray-gun before sending him onstage. This time, he looks downcast and a little fucked around with in a hoodie, a t-shirt in pale jonquil, and tattered jeans, his vibe unsettling enough that David Letterman feels moved to enquire as to whether everything's alright. "You look," Letterman adds, not exactly paternally but not entirely unkindly either, "as if something might have happened."

Whatever it is that happened — and there is an air that *something is not right*, as if the wheels were bound to fall off this entire interaction any second in the most peculiar and frightening way — Harmony Korine, when he is lucid, remains very, very funny. "I think it made a lot," he says, when Letterman enquires about *Gummo*, the hallucinatory Dogme nightmare he released in 1997, to reviews that could not decide whether it was the worst film in recent history or a work of modern art. "That's how I got my outfit." ("I had to rent it," he says, chuckling in a burbling stoner's register, about the shabby "little number" he is wearing. "I rented this.") Asked whether *Gummo* is in theatres, he says, "Yeah — yeah, it's been playing eighteen months straight." When Letterman says, of James Cameron's soapy blockbuster *Titanic*, "*that's* a movie," he replies, "I know it sank," before suggesting that he'd like to write a sequel "on a rowboat." It is 1998, and by this time it is fairly public knowledge that Korine — two of whose homes have recently burned down in what have vaguely been described as "mysterious circumstances" — is on heroin and crack cocaine, meaning that, although some of his eccentricity on *Letterman* is a performance, some of it is the result of his increasing alienation from the real, functional world. "I became like a tramp," he would go on to say in 2008, about the tail-end of the Nineties. "I wasn't delusional. I didn't think I was going to be OK. I thought: 'this might be the end.' I'd read enough books. I knew where this story ended. The story finishes itself."

Because Korine believed that, to be a "great" director, you needed "to go and rob a few banks, do some good crimes, put yourself on the line, to see if you have the stuff," he was not frightened by the idea that his lifestyle could eventually result in his own story finishing itself a little prematurely, ending up

as less of an American novel than a slim, pitch-black novella. "Go to jail for a few years, so you'll have some good stories to tell," he shrugged. "I think consciously insane behaviour should be a necessary part of life." If *A Crack up at the Race Riots* — a collection of vignettes that pushed the boundaries of good taste in every possible direction, as the title might suggest — did not succeed in fully capturing the American spirit in the way that he had hoped for, a film project he began to work on in the spring of 1999 looked as if it might do the trick. *Fight Harm*, a planned feature-length compendium of skits that featured Korine being horribly and genuinely beaten up by strangers, would be the precocious artist's *meisterwerk*, an experiment in "push[ing] humour to extreme limits" that he claimed would "demonstrate that there's a tragic component in everything [funny]," as well as being a document of the great American sport of drunken brawling. In his first *Letterman* interview, he had revealed that he once changed his name to Harmful, adding that he "thought it would [sound] tougher, 'cause I used to fight a lot as a kid."

Whether or not this is the truth, it is telling that he ends the story by suggesting that he changed it back to Harmony again: a boy named Harmony who fights all comers is funnier — more ironic and deceitful and unlikely and thus, ultimately, more Korine — than one named Harmful. (The mischievous way he says "not very good" when asked how skilled he was at fighting, impossible to faithfully reproduce here on the page, remains one of the funniest moments in all three of his appearances, the young filmmaker sounding more than ever like a perfect imp of the perverse.) Preternaturally babyish and sweet-faced, with a build like a teenager and the huge and limpid brown eyes of a fawn, Korine could not have looked more innocent of every stupid thing he'd done, nor more

unlikely to be serious when he challenged furious bouncers and muscular ex-marines to land a blow. Because of this, the fights took work: insults hurled, come-ons issued, objects thrown, the resulting chaos often seeing Korine being "chased in circles." After six months, he called time on *Fight Harm* due to various grievous injuries and legal issues, shattering his collarbone and ending up — like, he would no doubt say, a very great director — getting handcuffed and then briefly thrown in jail. To a casual observer, his behaviour might have seemed less funny-ha-ha than straightforwardly and dangerously funny *in the head*: not just "consciously insane," but deeply cracked. To Korine, it was a crack-up — a joke cruel enough that, although he had orchestrated it, it could just as easily have been played by fate.

"I couldn't really finish [*Fight Harm*]," he admitted to an interviewer at *Harpers* in December 1999, the novelty having worn off in light of how little footage he had managed to obtain:

It got to a point where I was getting really hurt and arrested and weird shit started happening... with *Fight [Harm]* I wanted to make a great comedy. I thought that was the best way to achieve it. I'd get a little drunk, but not so drunk that my motor skills weren't working. I did a few fights — one after the other. But what I didn't really think about was how short hard-core fights last. When you're fucking hitting each other in the head with bricks, it can only go two or three minutes, so out of the six or seven fights that I did, I have maybe fifteen minutes of pure, hard-core bone breaking... I would go around with a camera crew, and the only rules were that I couldn't throw the first punch and the person I was confronting

had to be bigger than me. That's where the humour comes in. It wouldn't be funny if I was fighting someone my size. They had to be bigger than me, and no matter how bad I was getting beat up — unless I was gonna die, that was the rule, unless I was like passed out and they were still killing me — they couldn't break it up. Because that's where the comedy comes in as well… that's where the whole Buster Keaton thing comes in. It's really high comedy.

Korine, quite often also really high, was not wrong to say that *Fight Harm* was the most extreme, most logical progression of a genre — slapstick humour — that relied on the twin pleasures of relief and *schadenfreude* to make viewers happy, their elation stemming from the fact that it was not them being pulverised. "A perfect pratfall is the definition of generosity towards an audience because its sole purpose is to make an audience laugh," the film critic Sheila O'Malley argued in 2012, writing about Cary Grant's supreme and masterful manipulations of his body. "When someone else falls, in a moment that is supposed to be dignified, we experience a catharsis. There is that element of: 'Oh my *God*, I am so glad that is not me.'"

Two decades later, Korine reaffirmed the deathlessness of his commitment to the joke — the joke being senseless violence — by describing his new tragicomic psychedelic stoner film, *The Beach Bum*, in the-same-or-similar terms. "Guy slips on a banana peel," he told a journalist at *GQ* listing the three funniest images that he could think of to explain his personal attachment to the age-old slapstick genre, "and smacks himself in the head. W.C. Fields falls down some steps. Buster Keaton [as a] bank teller." In that profile, *Beach Bum*

star Matthew McConaughey is asked to describe Korine's personality over email, and does an *alright alright alright* job of making him sound like a frightening, freewheeling kind of huckster, not exactly malevolent and not quite benevolent, either. "He demands that the world entertain him. His appetite for destruction makes him a birther [sic] of creations," McConaughey writes, probably a little stoned and thus inclined to be poetic. "He's inconsiderate, fair-weather, a great liar, will never promise anything, is non-possessive and has no affiliations. He needs controversy. To him, a boring person is a sinner." This last observation, pithy and near-aphoristic, gets at what might be behind Korine's desire to make a project like *Fight Harm*, as well as what is behind his career-long appreciation of the work of Buster Keaton. In *The Haunted House*, the film he references in passing in *GQ*, Keaton plays a clumsy bank-teller who first appears falling head-first out of a cab, then is sent flying by a swinging iron door, destroys a wad of notes with glue, sticks his right hand to his hair, pours boiling water on another teller's ass and then attacks him with a hammer, and performs a perfect backflip with his hands stuffed in his pockets, all within the first eight minutes of a twenty-minute runtime. His delicate, doe-eyed affect — helplessly destructive, but redeemed by a near-total lack of guile — makes it not only impossible to hate him, but so easy to adore him that the audience forgives him his transgressions instantly, the way viewers often do when people who behave like devils have the pale faces of saints. He repudiates the sin of boringness by being unpredictable, the chaos of him rippling across what was previously lifeless as if something very heavy — as heavy as love, or God, or the iron door of a bank vault — had been tossed into a lake.

What Keaton did in his best stunts was something close to the

sublime, an alchemical transformation of a mundane object like a murphy bed, a chair, a barrel, or a car into a conduit for magic. A scene from his celebrated 1928 film, *Steamboat Bill Jr*, in which he stands motionless as the full-sized, two-ton frontage of a house falls down around him, has become one of the most iconic stunts in cinema, a feat that might have killed the actor if he'd faltered by an inch. What kind of man would risk his life in order to produce a single striking image for a comedy film, even if that image happened to be so spectacular that it could barely be believed? As it turned out, the kind of man who'd had a singular and dangerous early life.

As a boy of two or three, Joseph Frank "Buster" Keaton found himself joining his vaudevillian parents in an onstage act that saw them tossing his small body back and forth as if he were a human pigskin, aided by a handle affixed to his back that resembled the handle of a traveling case. "We always managed to get around the law," he later said, "because the law read: No child under the age of sixteen shall do acrobatics, walk wire, play musical instruments, trapeze. And it named everything — but none of them said you couldn't kick him in the face." "Buster," being then-contemporary slang for "a considerable fall," proved to be as snug a fit as "Harmful" might have been for Harmony Korine circa *Fight Harm*; that the name was maybe apocryphally given to him by Harry Houdini only helped enhance its sense of mystical predestination. (Equally auspicious: he was born in 1895, the year the Lumière brothers first screened *La Sortie de l'usine Lumière à Lyon*, so that Buster and the cinema essentially shared a birth year.) As an adult in the movies, there were moments in which Keaton moved less like a circus tumbler than a dancer, a balletic symphony of minor movements adding up

to what looked like a single, clumsy breakneck crash, a single pratfall or a tumble down the stairs. His face, astonishingly lovely in those early Twenties two-reels, is more often than not minutely expressive, making him appear as modern for the age as Louise Brooks did when she first confounded a furious critic by "not suffer[ing], do[ing] nothing" in Pabst's 1929 *Pandora's Box*. The falling house skit, a conjuring trick that used no actual trickery aside from Keaton's willingness to suspend both his sanity and his desire to survive, cemented him as a pioneer of cinema so unlike any of his predecessors that he might as easily have come from space as Piqua, Kansas.

"To sit through dozens and dozens of short comedies of the period and then to come upon [Keaton's first short] *One Week*," the critic Walter Kerr wrote in 1990, "is to see the one thing no man ever sees: a garden at the moment of blooming." Because the blooming of a flower also hastens its demise, Kerr could not be more correct in his assessment — eventually, in the Thirties, a run of extraordinary work came mostly to an end with Keaton's unsuccessful move to MGM, the rise of talkies, his eventual bankruptcy, the dissolution of his marriage, and a slow slide into alcoholism, gradual at first and then committed, until *he himself* was briefly committed into a sanatorium. "When I was a dancer," the essayist Maggie Nelson told an interviewer in 2013,

we were always encouraged to fall in rehearsal, so that you could know what the tipping point of any given movement was. That way, when you did it on the stage, you could be sure you were taking it to the edge without falling on your face. It sounds like a cliché, but really it's just physics — if you don't touch the fulcrum, you'll

never gain a felt sense of it, and your movement will be impoverished for it.

In his life and in his art, Keaton touched the fulcrum again and again, feeling the danger and not flinching, his work proving Plato's claim that laughter is "a mixture of pleasure and pain that lies in the malice of amusement." The critic Anthony Lane, who describes Keaton's oeuvre as "screen comedy at its gravest and its most athletic," argued that his hallmarks were "irony and fatigue, high speed and hard luck, [and] the strong toil of grace." What was funny about everything he did was also what was human, fallibility and sensitivity being as much of a part of it as the ability to endure crash and smash. Grace, a word most often used to describe elegance in terms of movement, is of course also a word for what is God-given, defined by the theological dictionary as a form of love or favour from a higher power that is "generous, free, and totally unexpected and undeserved." Grace, found in the second before tipping at the fulcrum, is exactly what the best of Buster Keaton gives his viewers.

For a one-time junkie whose behaviour in his earliest onscreen interviews, as Letterman drily observed, helped to explain "why they invented child-proof caps," Korine has also maintained a connection to what might be described as a certain kind of grace. "The real world," he told an interviewer at *The Believer* in 2010, "isn't enough... a true mistake is some kind of magic — or maybe [it's] God." At the Venice Film Festival in 1999, he offered up a melancholy exegesis on the nature of true love, which he believed was as much a form of self-injury as anything he undertook for *Fight Harm*: "Sex and love," he said, "are only other types of suffering. I think that hope exists, but I haven't found it yet. Maybe it exists in film,

but not in life." His definition of romance echoed the poet Harmony Holiday's, when she wrote in 2016 about men and women in love being "attached to what hints at an ecstatic freedom of the mind, but is actually our most tender disaster after birth." ("Tender disaster," as a phrase, might have made an appropriate title for a memoir if Korine had thought to write one; ditto Buster Keaton, who ended up calling his, with a wry irony, *My Wonderful World of Slapstick*.)

Showing his hands to the reporter, Korine explained that he had had a pitchfork tattooed on one side and a crucifix on the other in order to represent the warring sides of both his character and his attitude to his work, half of him being enamoured with the idea of enduring as a world-renowned filmmaker, and half of him being enamoured with the notion of behaving like a mad god or a criminal and then dying as young as Fassbinder or Murnau. It is difficult, too, not to read this particular interview and think of Korine's Dogme forbear Lars von Trier, who has continued to suggest a propensity for confusing sex and love with suffering throughout his career, and who appeared at the end of each episode of his genius supernatural comedy *Riget* with an exhortation to *tag det gode med det onde* — that is, to "take the good with the evil," the joke being that the evil was what audiences came for, and that moral "goodness" is not necessarily an interesting quality in film or television — while first signing the cross, and then a playful set of horns.

Harmful on the one hand, and Harmony on the other, Korine's sense of humour sprang from an innate sense of his being contradictory — both hard and soft, a swaggering hipster and a fussy, nervous goober, as if one version of him pranked another version in perpetuity. In one of the "on set" photographs from *Fight Harm* that appeared in *Thrasher*,

the New York skate magazine whose merchandise has since become mysteriously popular with non-skateboarding Gen Z teens, Korine rolls the sleeve of his white shirt up to reveal what seems to be a puncture wound, an unlit joint dangling limply from his mouth. There are shades of the photograph taken in the immediate aftermath of Chris Burden's performance *Shoot*: the same white tee, the same bright red, annular wound. Burden wrote ahead of that performance, in a listing in the underground art publication *Avalanche*, that he planned to get "good photos" of the piece. The resulting image *is* an undeniably good photograph — a compelling portrait of the artist not just as a young man, but as a man young enough to feel that he has proved his indestructibility by cheating death. Like Korine, Burden looked a little juvenile when he was in his twenties, his cherubic baby-face lending itself to images that positioned him as a counterculture brat. There is a crucial difference, though, when it comes to the *mood* of both publicity shots. The cool, old-school masculinity of the *Fight Harm* image — the young filmmaker's impassive look and flexing golden bicep; his unruffled, distant gaze — becomes hilarious in context, with the context being that this is a photograph of Harmony Korine: an antic, pint-sized chaos agent with a neat line in one-liners and the nebbish, faltering delivery of a stoner Woody Allen. Always, there has been a little of the Borscht Belt comic in his sensibility, even when he has been half-cut or blitzed or shy or barely comprehensible — a note of something out-of-time in spite of the furiously contemporary nature of his work. In a *Guardian* interview from 2008 that calls him "Groucho Marx on amphetamines," he is described as an "eccentric intellectual, who can hold forth on... 'the essential cruelty of comedy,' with particular reference to Buster Keaton and Samuel

Beckett." There may be no more illustrative example of his cross-generational, fogeyish cultural consumption than his minor role in *Kids*, the curiously alarmist film he wrote about HIV-positive teenagers having sex when he was just nineteen years old, playing a dealer in a nightclub: "You'll be floatin' up in heaven with the angels," he tells Chloë Sevigny's Jennie, wearing magnifying glasses that make him look *literally* like Groucho Marx on amphetamines and a sweatshirt reading NUCLEAR ASSAULT. "You'll be singing with Sammy Davis Jr — you'll be kissing Leo Gorcey on the chops!"

No nineteen-year-old skate freak, from New York or otherwise, would think to mention Leo Gorcey in a drug deal, unless that nineteen-year-old skate freak were Harmony Korine; no other cool, young Gen X author and director would, as Korine does on page 26 of *A Crack Up at the Race Riots*, find it funny to imagine that the late Montgomery Clift might have enjoyed a scene in Henry Fielding's *The History of Tom Jones* enough to write "a little coitus never hoitus!" in the margins. Other hip Gen-X-ers *do* cite — and even pay direct homage to — Buster Keaton, whose alembic of delicate beauty and immortal-seeming fearlessness still conjures something that has not yet been repeated or improved. "I love Buster Keaton," a hungover Johnny Knoxville told *TIME Magazine* in 2006, in an interview promoting *Jackass Number Two* — a film in which he recreated, once successfully and once extremely unsuccessfully, the house stunt from *Steamboat Bill Jr*. "It's amazing how timeless [Keaton] is, and how that kind of physical comedy will never be unfunny. How many filmmakers can you say that about?" Knoxville asks, in the 2018 documentary *The Great Buster*. "Buster's always been with me and always will be with me. Our stunts always play in the wide, there's no fudging — the guy doing the stunt is

doing it for real. And he felt very strongly about that, and I feel very strongly about that." Of the many famous faces in the documentary, Knoxville may be the most obvious heir apparent, even if he is not quite the consummate actor Keaton was — where some might theorise about or satirise or pay homage to the things Buster Keaton did, he either riffs on them or apes them, adopting the same casual attitude to grievous risk. In the *Jackass Number Two* finale, the cast perform various stunts while on sets that resemble something from a Busby Berkley musical, singing "Make This Moment Last" from 1978's *La Cage aux Folles* with tuneless glee. Dressed in black as a gunslinger from a Western, Knoxville stands with his chin coyly on his fist as a saloon set falls exactly as the front of Keaton's house did, his pose perfectly aligned with the three-foot-by-three-foot opening of a window. Underneath the credits, we see what happened the first time: stepping forward just a little off his mark, he ends up folded horribly beneath the set as it comes crashing to the floor. "Medic!" someone yells off-screen, as the ignominious credit "Beer provided by the Miller Brewing Company!" scrolls past Knoxville's crumpled body.

"My head went through the window," he said later, "but my body got smashed. If my head had been smashed, it would have killed me. We even had a stunt co-ordinator that day. We never have a stunt co-ordinator. He told me not to move. I moved." "I think that the fact that he is the least fucking coordinated guy ever is what makes his stunts so amazing," Steve-O told *GQ* in 2021. "So many of us grew up on a skateboard, sort of developing a natural instinct for falling down. Knoxville doesn't have any of that, so when Knoxville falls down, it's like, it's devastating." His lack of coordination is exactly why it's true when Knoxville says

that it is funnier that he fails where Keaton — as he always did, as weightlessly as if each pratfall were a dance move being performed by Fred Astaire — succeeded. Knoxville's charm lies in his roughness, allowing him to be at once a three-dimensionally embodied Warner Brothers character, and a chill dude who enjoys being shot out of cannons. "We watched a lot of cartoons while writing *Jackass 2*," he gleefully told *TIME*. "I saw one where Tom puts on a blindfold and a bull comes along and just smokes him. I thought it was a pretty good idea for the movie, so we got an 1,800-pound yak to do the same to me." The yak had to be big to up the stakes: in the show's very first season, Knoxville had already ridden, and then run from, an enormous Texas longhorn by the name of "Mr Mean." For a *Jackass 3D* stunt, he had the idea of producing a colossal papier-mâché hand, palm out, that could administer a high-five to the body of an unsuspecting victim as they walked around a corner — in one version of the skit, he has convinced an unwitting Ehren McGhehey to deliver a tray of soup to the rest of the *Jackass* cast, and the image of McGhehey carefully wobbling around the corner with his precious cargo is deliriously funny and heart-breaking in exactly the same way as seeing Wile E. Coyote realise he is running on thin air. "He fell for the soup!" Knoxville yelps delightedly, clasping his hands behind his head in disbelief. In *The Great Buster*, in a clip from a 1972 episode of *The Dick Cavett Show*, the director Frank Capra says that Looney Tunes cartoons were what put Keaton out of business — "and then Chuck Jones," Peter Bogdonavich adds, "who directed most of the great Bugs Bunny and Roadrunner cartoons, said he was totally influenced by Buster Keaton." The *Jackass* boys, affable and always keen to take their lumps, have successfully bridged

the gap between the superannuated silent-era stuntman and the Looney Tunes cartoon.

"Unlike narrative-based mediums," the critic Jason Concepcion suggested in 2018, "a stunt doesn't need any setup. They render the taxonomies usually deployed to divine deeper meaning from sound and images practically useless... A stunt is simply a very bad idea, undertaken with total commitment." A bad idea, executed with full commitment, can be transmuted into a good or even great idea if it is suitably interesting, unexpected, dazzling, or entertaining. It can also be transmuted into art — an act of conceptual significance, meant to elucidate some facet of society or culture that is in itself *a bad idea*, whether that facet is war, sex, love, patriarchal violence, or a yen for self-destruction. Whether the practitioner believes his or her bad idea to be conceptually significant rather than simply an amusing, violent goof is one way for an audience to determine whether they are watching art or entertainment. "Performance art is one thing," Johnny Knoxville once insisted,

and performance artist is another. Performance artists are always so goddamn self-important, intellectualizing everything they do. I don't intellectualize anything I do. I'm kind of uncomfortable with that term ["performance artist"] because it just comes across as highbrow, elitist, pompous and not entertaining. We're just trying to make you laugh. We're like the Three Stooges, except we're doing it for real.

Chris Burden loved, but did not feel a particular kinship with, Evel Knievel, the stunt rider who apocryphally broke every last bone while leaping mountain lions, rattlesnakes, cars and

cargo vans on a Harley-Davidson XR-750. "Evel Kneivel is a stuntman," he insisted, after being described as "the art world Evel Knievel" one too many times, "and he makes a stuntman's kind of art. He's a trickster, and I'm not a trickster. Everything I do is for real."

That Knoxville prides himself on "doing it for real," and that Burden recognises that there *is* in fact "a stuntman's kind of art," makes it difficult to know exactly where to draw the line between what both of them achieve with the destruction of their bodies. It is interesting, too, that Knoxville has no problem with performance art per se, instead thinking that the practitioners who create it are too "goddamn self-important" for their own good — in *The Artist Is Present*, for example, Marina Abramović, in spite of the asperity of her public image, proves herself to be not only capable of laughing at her reputation, but of making us laugh with her at the same time. "If I put [out] advertising like that, do you think it will attract some guys?" she deadpans, after shooting a promotional campaign where she is dressed as an extremely busty devil in a corset, before offering up a logline for the ad: "Semi-intellectual artist at the top of her career seeks single guy." "Sex is so funny!" she informed a startled journalist from *New York Magazine* in 2015, before telling an old wives' tale from her native Serbia: "Put a fish in your vagina, wait through the night, in the morning put it in a man's coffee. Do this and he will never leave you." ("But of course," she added, maybe joking about Ulay, "it didn't work for me!") "People know my work and they're afraid to meet me," she chuckled in a TED Talk the same year. "Then they get to know me *and* my work, and they think I'm hilarious." "How many hours does it take for a performance artist to change a lightbulb?" she asked in a video promoting The Marina Abramović Institute

in 2013, fudging the punchline several times so that the video ran to seven minutes before eventually getting to the point: "I don't know, I left after six hours." "Now that I'm nearly 70 — 70! — I just want to be hilarious," she echoed to the *FT*, in an interview in 2016. "And tell jokes. In my country, jokes are always about survival. Heavy."

Some of her performance pieces look like heavy jokes about survival, too — a fact spoofed in an episode of the satirical faux-documentary series *Documentary Now!*, inspired by *The Artist is Present* and entitled, drolly, *Waiting for the Artist*. The tall, otherworldly Australian actress Cate Blanchett plays a world-renowned Hungarian performance artist by the name of Izabella Barta, who is in the midst of planning her first major retrospective for a gallery in Budapest. Styled just like Marina Abramović, with long obsidian hair and skin as smooth and pale as cream, Blanchett's most impressive piece of mimicry is her uncanny recreation of the artist's faltering laugh: a kind of breathy catch that often interrupts her sentences like an ellipsis. We first meet her doing the same vixenish photo-shoot with corsetry and devil horns Abramović does to promote her show at MoMA, fretting over the idea that she may no longer have any new ideas. "I jump out of your closet one night, and it is a real shock," she says, pouting and arranging her face in a way that makes her look as if she might have recently had plastic surgery, "but I do the same thing for thirty years and at some point you're going to say to me, hey, get your own closet to hide in!" Hoping to recapture the punk spirit of her youth, at one point she proposes hanging her old works, pouring gasoline over the gallery walls, and then escaping as the building itself goes up in a blaze. "Art is not supposed to be safe!" she shrugs. "Art is supposed to be radical!" As in Jeff Dupre's and Matthew Akers' original documentary, her

career is introduced with a long montage of old works, many of which are nominally spoofing real works by Abramović: *Gender Roles on Spin Cycle* (2005), in which she wears a khaki Mao suit to be put through a spin-cycle in an industrial-scale washing machine; *Birth/Death* (1976), in which she stands in an abandoned warehouse wearing a nude bodysuit affixed with targets, and cries "Birth! Death! Birth!" as tennis balls are fired at her body by a ball machine; and *Domesticated* (1977), in which she drinks milk from a bowl while shouting "I am human! I am human!" with a fur coat on her back.

The *pièce de résistance* as far as Izabella Barta's long career is concerned is, the show reveals, a sequence called *The Bucket Series*. A white-haired curator named Arvidis Sprout — meant to stand in for Klaus Biesenbach — describes a scene that unfolds following the placement of a rotary telephone in the middle of the gallery. "The men in the room were invited to place objects on the floor — mouse-traps, roller-skates, and so on," he recalls. "Then, once the floor was littered with dangerous objects, everyone would take their seats. After a moment, the phone would ring, and Izabella would charge into the room with a bucket on her head." At this moment, we see footage of Blanchett as Izabella Barta crashing helplessly into the space wearing a bucket on her head, treading first on broken glass and then a skateboard, her long body thumping heavily to the ground in a pratfall so classic and so total that it might as well have been performed by — who else? — Buster Keaton. On the bucket is a crude and childlike drawing of a face, still smiling dumbly. "The show," Sprout adds, "was extremely popular with teenage boys." It is a dark joke, hinting at the drive in certain young men towards hurting and humiliating women. Obviously, the work being alluded to is *Rhythm Zero*, with its similar exploration of male

viewers' intrinsic longing to mete out punishment on any beautiful young woman who is bold enough to offer them an opportunity for unpoliced, unfettered violence. "[*The Bucket Series*] was a great piece," a young female critic says, "because it showed how bestial an audience could be when given a chance. They could have cleared a path for her. But instead, they put her in peril. And no matter how badly she fell, or how many things she ran into, the face on the bucket remained happy. And that façade — that smiling bucket — is what it means to be woman." The joke is in the fall — it is also in the accuracy of the piece, its hair's-breadth nearness to a real idea by Marina Abramović. Is the critic wrong when she says that a smiling mask is "what it means to be a woman"? Not exactly.

If the humour in this episode of *Documentary Now!* is meant to arise from the fact that it recognises the self-seriousness of most performance art, and of Marina Abramović's performance art especially, it does not land entirely smoothly. I said earlier that Marina and Ulay's 1976 performance, *Relations in Space*, "literalised, almost comically, the supposed 'battle of the sexes.'" Watch it after *Waiting for the Artist*, and the qualifier "almost" feels suddenly like an error: to see both of them stark naked, running blindly at each other and remaining stony-faced despite the loud, echoing slaps of flesh impacting flesh at speed, is to wonder just how *un*like a joke *Relations in Space* is meant to be. When they walk, they stomp like two skinny Neanderthals, determined but unmoved. At one point, Ulay's forehead makes direct contact with Marina Abramović's forehead with such evident, blunt force that she is thrown straight on her ass; rather than acknowledging that she is injured, he turns tail and then strides coolly and impassively off-camera. As far as gags about casual male violence go, this one is better than the one about teen boys

enjoying Izabella Barta's very public self-abasement — sex and love, as Harmony Korine once said, are only other types of suffering. What the work implies is that relationships between heterosexual men and heterosexual women are inherently debasing, full of conflict, and apt to result in bruising; those who have the upper hand will lay waste to their partner, and then step away as casually as if nothing had happened. Or, to put it as a joke that is immediately recognisable as one: *What's the difference between a relationship, and two people running headfirst at each other with their clothes off until somebody gets seriously hurt? Absolutely nothing!*

In a video work from 1974, the German body artist, sculptor and filmmaker Rebecca Horn slices off her long red hair with two large pairs of vicious scissors, moving ever closer to her cheeks and lashes with each snip. It has the feel of something that might have been dreamt up as a faux-historic work for *Waiting for the Artist*: the tight shots of blades advancing perilously towards her eyeballs, the ridiculous cropped mushroom shape her hair ends up assuming, and her dead-eyed solemnity in the face of such humiliation all conspire to make the video bleakly, darkly funny, as if Horn were heartbroken and not quite sober and attempting a post-breakup reinvention of her style. Overlaid, a man describes the violence of male animals' combat rituals, and suggests that they are sometimes mistakenly seen as courtship rituals, instead – "the most conspicuous difference" between combat rituals and mating rituals at any rate, he says, lies in the fact that, in the latter, "both partners take an equal part in it." Horn's 1990 feature-length film *Buster's Bedroom* — in which a young woman with an all-consuming love of Buster Keaton travels to the sanatorium, Nirvana House, where he once stayed — begins with a monologue from its heroine addressed

directly to the actor: "Why do you always search for danger? Is it to have a reason to escape? You're not afraid at all. In the back of your mind, maybe you are. You don't need help. You would run away from it, anyway; keep to yourself. There's nothing left to lose." Her father, a precise and gifted pianist and composer, has recently passed away, and the love she feels for Keaton is as much about the longing for a father figure as it is about desire; driving to Nirvana House, she wears a blindfold, as if she expects the dead star to inhabit her in one last act of derring-do. Horn herself ended up in a sanatorium at the age of twenty, poisoned by the fibreglass she had inhaled while making sculptures, and while she was staying there, her parents died. She became fascinated by the vulnerability and sensitivity of her body, the way it could be destroyed by things she loved, betraying her by never quite being as powerful or unbreakable as her mind. Much of her career was spent producing items to be worn, as prosthetics or adornments. She, too, was obsessed with Keaton, believing him to be similarly inclined to sacrifice his health in service of his art, similarly fond of dreaming up ridiculous, surreal machines and apparatuses in order to bend the real world to his will. "No wonder one of her heroes is Buster Keaton," Jeanette Winterson wrote in the *Guardian* in 2005. "Comedy and pain share the same vein in her work. She makes us smile, laugh, and then comes the pause, and very often, the discomfort, but the seriousness and the playfulness have to run together."

"We are raised to believe that great works of art require suffering," says Dimo, *Waiting for the Artist*'s lazy, boorish and conceited Ulay proxy. "I want to show that, no, the opposite is true." Dimo's practice, which prior to meeting Izabella relies more or less on pranks and random combinations of quotidian objects, centres around the idea of making pieces

with "no thought and no time," as a radical rejection of what he perceives as a disproportionate focus in the art world on the meaning of, and the agony inherent in the creation of, the work. It is difficult to know whether the writers are more critical of Dimo for his laziness, or of Izabella for the feverish intensity she devotes to scenarios that might technically be performed by anyone at all, assuming that they'd had the idea and the gumption. "What [Izabella Barta] does is impossible to replicate," a talking head says, over footage of the artist that depicts her scribbling on her face with lipstick, à la Diane Ladd in David Lynch's 1990 film *Wild at Heart*, and then swallowing the tube. "My kid could have done that" is a criticism levelled at conceptual and abstract art often enough that the phrase has become a cliché — notice, though, that it is usually only parents who are wowed by the art made by their own children, in stark contrast to the very real emotions experienced by, for instance, those who cried or otherwise broke down while sitting opposite Abramović for *The Artist is Present* at the MoMA in 2012. This is something the performance artist, the comedian, and the stuntman have in common: an ability to conjure, often using very little means other than courage and inventiveness, an immediate reaction from the viewer, whether that reaction happens to be laughter, relief, *schadenfreude*, horror, terror, psychic agony or spiritual ecstasy. It is shocking to consider how close Abramović came to being shot in *Rhythm Zero*, just as it is shocking to read about injuries sustained by famous men who trash themselves for entertainment. In both cases, we could broadly commend this as a commitment to the bit.

"In my life," Abramović said in 2013, "I took so many risks, and I would never know if I was going to fail. But I did know that if I did the same thing over and over again, I would create

habit." Two things are often said to improve after repetition: comedy, as in the "rule of threes" that often governs jokes in screenwriting, and focus, as in meditation. Making *Fight Harm*, Harmony Korine believed he was creating something simultaneously hilarious and philosophical, its repetitions flattening the impact of its ugly scenes to clear space for what he described as "epic humour" — "epic" not necessarily in the sense of *epic, dude!*, but in the sense of something heroic or grand. "Maybe, in a misguided way," he mused to the comedian Marc Maron on the podcast *WTF* in 2015, "I really wanted to make a perfect comedy, and I thought that pure violence, and the repetition of violence, would [achieve that]. I thought it would just build. I thought the repetition of the violence would just negate it, and it would just build and build into something humorous." If one of the things Korine loved about the idea of *Fight Harm* was its nearness to the sick jokes played by fate — sudden bursts of unexpected violence meted out at random, with no rhyme or reason, on a stranger — he also saw his orchestration of it as a means of taking back control over his own unravelling life, merging himself so thoroughly with his art that it no longer mattered much whether he lived, whether his teeth were falling out, or whether he was still an addict. "It was a strange time in my life," he tells Maron, falteringly, as if he still doesn't see this as a problem.

It was a strange time because people were genuinely concerned, or people thought I was losing it. The truth is, I knew what I was wanting to do. I was really ambitious with that. I remember there was this thing that people would say: "you don't know where your life ends, and

your art begins." And it wasn't that I didn't know. It was more that I *wanted* it to all be the same.

When he talked about pain back then, it was often to suggest that it was a familiar feeling, making it an obvious subject for his jokes: "I'd get off on [it]," he said in *Harpers*, wryly, the image of skinny little Harmony as a bona fide masochist being funny, too:

> Because as a kid, growing up in Tennessee, violence was just a way of life. Everybody, no matter how big you were or anything — I'm a teeny guy, and I was even a smaller kid — but it was like no matter what, you had to fight. It was one of those things, a real redneck thing. Violence was part of life. I hated getting hit, but I never minded it so much when it was a fight.

Korine, whose father was a documentarian who made films for PBS, was not exactly a hillbilly, having spent the first part of his life in a Californian commune, and having been taken to see Werner Herzog's *Even Dwarves Started Small* at the movie theatre as a kid. Still, "redneck" life appealed to him because of what must have appeared to a precocious, bohemian middle-class kid with an aptitude for spinning yarns like mythic qualities — the perfect subject for a person who would go on to identify himself as "the most American director in the world." In the stories Korine told on *Letterman*, strange men he had invented did strange things, or had strange things visited on them by the universe — the boy named Barfunk whose boat Harmony claimed to have accidentally capsized, the guy from Delaware who stuck a skewer through his ass-cheeks and then had to buy "expensive special pants" — as if

they were archetypal characters from darkly comic folk tales. In his films, the same applies. It is funny to see "teeny" or otherwise ordinary people battling the bigger world around them, their tininess or ordinariness lending them a David-and-Goliath heroism even when they fail to triumph. There is, too, another reason people like to see the little guy in peril, which is that it makes them feel significantly less like little men themselves. "The passion of laughter," Thomas Hobbs once wrote, "is nothing else but sudden glory arising from some sudden conception of some eminency in ourselves, by comparison with the infirmity of others." Those who make us laugh by injuring themselves are, by this definition, birthing sudden glory, an unhinged act possessed of an almost mystical significance. Harmony Korine, who said of *Fight Harm* that he'd never shown the tapes because the real thing could not live up to the ideal in his head, remained reverent at the thought of pain as the ultimate form of clarifying, unifying humour, even after he got clean, got well, became less "teeny," and became the father of a child, as if some part of him envied the abandon of his earlier, more fucked-up self.

"Whether he is suffering the impact of the gags or willing them into being is hard to tell," Anthony Lane says of Buster Keaton, "but they flock toward him as though his very nature were a kind of magnetic north." Think of a person doggedly willing a dangerous catastrophe into being, and the image of the façade of that house crashing around him springs to mind. What kind of man would chance his life in order to produce a single striking image for a comedy film, even if that image happened to be so spectacular that it could barely be believed? According to his third wife, Eleanor Keaton, a man who was sick and sad enough to hope that he might die — an alcoholic whose imploding marriage and frustration with his film career

led him to take a risk so grave that crew members excused themselves before the stunt to avoid witnessing a suicide. The "mark" he stood on, keeping him from being pulverised, was a single nail he'd hammered in the ground. He was thirty-three, his Jesus year, and things would never be as weightless or as dazzling for him as they had been when he first became the familiar, youthful Buster Keaton so beloved by Knoxville and Korine, by Horn and by the heroine of Horn's spooky and abstract film. What blazing genius, borne of what might have been vivid psychic pain, and how funny it still is in spite of the fact we know about his suffering, watching him succeed in narrowly escaping certain death. "I was mad at the time," Keaton later said, "or I would never have done the thing."

IV. BABE, IF I KILL YOU, WHAT'S GOING TO HAPPEN TO MY LIFE?

The late writer, sadomasochist, and artist Bob Flanagan often said that every article about him had the same opening lines: "Bob Flanagan should be dead. But he's not." We know that Bob Flanagan finally died in 1996, not only because his obituary confirmed it to be so, or because *Artforum* ran a remembrance by the writer Dennis Cooper with the perfect title "Flanagan's Wake", but because his passing has been documented in rare and unflinching detail. In the 1997 film *Sick: The Life and Death of Bob Flanagan, Supermasochist*, Flanagan, who suffered from cystic fibrosis all his life, is recorded in the final moments of his life, drowning in the phlegm produced by his own lungs. Just before he dies, he manages to draw enough breath to explain to his beloved wife, the artist Sheree Rose, what it feels like to be half out of the world, and half within it. "Every day, I wake up and I think, am I dying?" he says, sounding baffled, as if he is trying to solve a mathematical equation. "I don't understand it. What is going on? This is the weirdest damn thing. This is the stupidest thing. I don't understand it." It is fascinating to imagine being face-to-face with death itself and finding the experience as inexplicable as it is terrifying, beyond human comprehension in its scope — Flanagan was right to say that dying, the most inevitable thing

we do, is also both the "weirdest" and the "stupidest," second only to the accident of being born. Photographs taken by Rose after his death — his body in the bed in hospital, his lifeless hands and open mouth, the quintessentially 1990s tribal-cum-barbed-wire tattoo near his penis — show the truth of death in the easiest possible way to understand: there is, suddenly and very clearly, no *there* there, so that while the subject of the photographs closely resembles the man formerly known as Bob Flanagan, it is quite obviously no longer a man at all, but an object in one's shape. Previously more alive than most, he turns the line between the living and the dead from a mysterious hair's breadth into a marker as obvious and imposing as a horsewhip.

This radical act of demystification was a logical conclusion to his years of laying bare, both literally and metaphorically, his chronic illness and his sexual proclivities, i.e., his cause of death and the preferred cause of his little deaths, respectively. The phrase "*la petite mort*," first used to describe an orgasm in 1882, is inspired by the closeness to another, unfamiliar realm suggested by both climax and expiry, both moments proven instances of the flattening of the individual self. "The feeling of embarrassment in regard to sexual activity recalls, at least in one sense, the feeling of embarrassment in regard to death and the dead," Georges Bataille argues in *The Tears of Eros*. "'Violence' overwhelms us strangely in each case: each time, what happens is foreign to the received order of things, to which this violence each time stands in opposition." Violence that behaved in opposition to the received natural order of the universe was, in some ways, the guiding force of Bob Flanagan's art career, in addition to that of his sadomasochistic lifestyle; a self-described "supermasochist" who was expected to die before he was twenty-one years old,

he maintained that his interest in S&M was what allowed him to live two decades over his life expectancy, playing God not by attempting to subtract pain but by doggedly, hornily adding it until his sex life and the slow progression of his fatal illness became muddled. If he ever felt embarrassment about displaying his tastes, he did not show it. "Bob was an exhibitionist," Dennis Cooper recalls in that *Artforum* obituary, "and Sheree loved to shock people, so their rampant sexual experimentation became very much a public spectacle. It wasn't unusual to drop by and find the place full of writers, artists, and people from the S/M community, all flying on acid and/or speed, Bob naked and happily enacting orders from the leather-clad Sheree." Performing a song about himself to the incongruous tune of "Supercalifragilisticexpialidocious," Flanagan would invariably add a lyric that made audiences gasp: "Um-diddle-iddle-iddle-I'm-gonna-die," he would sing, grinning like a naughty schoolboy who has just learnt some new, inappropriate slang word and is thrilled to be the centre of a scandal. "Um-diddle-iddle-iddle-I'm-gonna-die!"

In 1962, he appeared as an actual schoolboy on an episode of *The Steve Allen Show*, brandishing a collaged artwork he had made and looking like a perfect angel. "There is a youngster out there [in the audience] who is willing to trade a work of art for a salami," Allen says, in a moment that presumably made more sense to contemporaneous viewers of the show. (Flanagan, it must be said, certainly made extensive use of his salami as an artist in adult life, although not necessarily in a way that would have made it onto *The Steve Allen Show* in the early 1960s.) "Would that young man stand up, please?" The camera, once the house lights have been raised, cuts to a boy, all jug ears and baleful eyes, clutching a three-dimensional canvas to his chest and seeming nervous. "You're

a fine-looking young fella, how old are you?" Allen enquires, and with disarming little-man seriousness, Flanagan chirps "ten" and then immediately corrects himself: "Goin' on ten!" The artwork, a mix of collage and painting that sees several identical photographs of the show's host paired with a handful of expressionist renderings of his face, has a 3D television at its centre; it looks less like the work of a nine-year-old than it does like the work of an adult outsider artist with a taste for Robert Rauschenberg and Eduardo Paolozzi, or perhaps that of a germinal serial killer with a Hinckley-Jr-style fixation on Steve Allen. "Are you interested in becoming an artist, Robert?" Allen asks him, and he shakes his head, denying it. "Well, you do seem to have talent," Allen notes. "You may be able to fall back on that in future years. What are your interests, if any, professionally speaking?" It is either a tremendous cosmic joke or a mark of Bob's preternatural self-knowledge that he says, immediately and fervently: "To be a doctor."

In addition to being a raging pervert, was Bob Flanagan a doctor — his own personal physician, at least — or was he an artist? Like an illusory seeing-eye diagram, he could be said to be both per the viewer's mood and sensibility, to say nothing of their tolerance for watching men happily drive nails through their cocks. The things he did or had done to him were at once unconventionally therapeutic and traditionally ritualistic — all that bloodletting as much of a relief as getting off. Bodily fluid, whether it was blood or semen or the mucus that regenerated ceaselessly inside his lungs, obsessed him; every new opening he cut into his body felt suggestive of a surgical procedure, as if it might help him breathe or release pressure, like a stoma. When he made a sculpture of the Visible Man, the transparent medical model used to teach human anatomy,

he made it ooze from every opening, lime-green phlegm and softened shit and pale, emulsive cum, as if to suggest to the audience that the membrane between his disabled state and their able-bodied one was permeable, fragile enough to be meaningless. All bodies shit, and piss, and vomit, and all bodies eventually die, even if some die in their nineties and some have been told to expect death as soon as they have hit their twenties; if you cut a prick, whether or not that prick belongs to a man who is unwell, does it not bleed? Bataille's theory about the proximity of death and orgasm, both offering flashbulb glimpses of an unfamiliar world, is correct: no two experiences make us feel more like passengers in our physical bodies, moving us inexorably towards an endpoint that feels uncontrollable and overwhelming (or, as Bataille would say, "violent"). If Flanagan was passing through the world in a less functional kind of vehicle, he was still travelling to the same significant and metamorphic destinations, making the work he produced about his journey — both sexual and thanatocentric — instructive in the most unsettling way.

It helped that, in spite of the hand he had been dealt, Flanagan was always funny, his performances verging on stand-up comedy even when what he discussed was his nearness to being dead, or the way it felt to have a lit cigarette shoved into his waiting ass. (His poetry, a precursor to his art and to his sexual awakening, is more notable for being amusing than it is for being great: "What's wrong with you? she asks," he writes, in 1980's wry "Bukowski Poem." "Oh, nothing, I say, it's just that/I'm starting to write like Bukowski.") When he read a text about his sex life, he would often tug his collar cartoonishly when the material either got too hot or too outré, a charming and disarming tic that made what might otherwise have been gothic into something merely offbeat. Like the joke

about the great clown Pagliacci being prescribed a ticket to see a performance by the great clown Pagliacci as a treatment for his crippling depression, he provided a remedy for the greatest fear on Earth by virtue of his direct experience of it, breathing pain the way his audience breathed air.

In 1980, he met an ex-housewife and punk-feminist photographer named Sheree Rose, their immediate connection ushering in not only one of the most touching and unusual love stories of the late twentieth century, but a sexual and creative partnership that lasted sixteen years. A decade older than her lover, Rose was a committed full-time dominatrix, usually pictured snarling from beneath a severe, glossy haircut dyed the nightshade colour of a pair of slippery vinyl pants. There may be no photograph of the adult Flanagan in which he looks more like the proud and uncool boy who appeared on *Steve Allen* in the sixties than one of the couple posing at their wedding, poised to cut the cake and seeming like two polar-opposite halves of one perverse and happy whole. He is in white; she is in vampy, low-cut black. Somewhat uncharacteristically, given their usual sexual dynamic, it is Bob who holds the knife. As soon as they met, Flanagan announced his longing to devote his life to slavery, eroticising the idea of living as a masculinised Cinderella figure in the basement of her home, cooking and cleaning and being tortured, sometimes going to the ball to get whipped, kicked and pricked with needles in front of a crowd of strangers.

The work he was making changed, the two of them immediately as co-dependent and conjoined as life and death, or death and orgasm. All of their art was about sex, and all their sex was elevated into art —Sheree Rose, documenting their sessions with her camera and Flanagan keeping notes, making the latter into *The Fuck Journal* in 1987. Diaristic and

explicit, that book acts a precursor — foreplay, say — to Flanagan's posthumously published sequel, the extraordinary and unflinching *The Pain Journal*. Where *The Fuck Journal*, for all its consensual violence and unconventional sexuality, could be written off as humorous or erotic, its follow-up was revealing in a different mode entirely, covering the period in which Flanagan was not just dying in some abstract, promised way, but quite literally close to death. "Every now and then," he writes, "a little hammer hits my head, and I realize: I really am dying. It's not a joke or a performance or a dramatic story. It really could happen at any time." It is the first time that the idea of being struck does not excite him. Because the book was not released until 2001, several years after his death, it offers up an afterimage of the artist to a reader who is watching him disappear in real time — his bravado being drained, the needle of his self-awareness suddenly acute and piercing. He is funny, but with an increasing lag between his jokes; he is horny, but not quite in the deranged, priapic way we might remember from his earlier, kinkier work. Over time, his love of pain begins to sour and then fade, and then vanishes altogether, commensurate with his suffering. He is no longer a masochist, but a man much like many other dying men, nakedly desperate to survive. "I used to talk about using pain to reach an altered state," he sighs, nearing the end,

[I would say] "I'm high as a kite on a drug called pain." Well, this kite has had all the wind knocked of it. Some part of me is still a masochist, but I can't fight the shortness of breath — well I can fight it, but in order to do that I have to surrender to it, and that means moving slowly, sitting still, and doing absolutely nothing. S/m requires

a certain amount of running around, and a lot of mind over matter. Fuck it, I'm tired.

The Pain Journal, despite being almost impossible to read, may be one of the most significant gifts ever bestowed on the world by a dying artist. The question of what happens when we die is less impossible to answer than the one about what happens in the immediate aftermath of death — the eventual failures of the body are a unifying curse, at least until a billionaire who underpays his federal taxes and obsesses over going into space invents a pill for immortality. It is rare to receive detailed, candid missives from a person who is dying, and more unusual still for them to be delivered in a voice as honed as Flanagan's: a little cracked, vicissitudinous, oscillating between humour and despair, honest about the degree to which he misses being a pervert in the way that certain other writers close to death might rhapsodise about being young or hip or vital. All that sexual disclosure does not end up being a way to avoid emotional frankness, but a note in harmony with it, as if Flanagan were layering a buoyant, sanguine melody with horrisonous screams to create something full and singular; not pleasant, but illustrative of the complexity of dying. Sometimes, he is wistful, noticing a chasm opening up between himself and Sheree Rose because of their eventual inability to perform S&M as he sickens. "Thought I'd escape writing tonight," he muses at one point, a little sadly, "but found myself mulling over why it is I don't like pain anymore. I have this performance to do on April 1st, and I'm shying away from doing or having SM stuff done to me because pain and the thought of pain mostly just irritates and annoys me rather than turns me on. But I miss my masochistic self." Missing a version of oneself, a deadening rite of passage even

for the living, must become almost unbearably acute for those who know that they will soon have no selves left to miss at all. "Pain pain pain," Flanagan spits. "Odd that what was once the fuel that ignited my soul has become the very thing that dampens my spirit. It just ain't fun no more. And for Christ's sake, it's all I talk about isn't it?"

It is, and isn't. When Flanagan writes about his pain, he is also, really, writing about the cruel disconnection that occurs between a well mind — "sick," perhaps, to use Flanagan's favourite word, but then not truly — and a body that is sputtering, flickering out. Who do we become when the specific apparatus that allows us to exist, to be embodied and to act out our desires, no longer behaves the way we want it to? The assurance that a person who is dead is no longer in any pain is little comfort to a dying supermasochist. All those contiguous entries about agony and fear have a hypnotic, numbing effect, revealing the way death begins to occupy every last thought in someone moving inexorably towards it at high speed. "Lately I'm thinking about cutting my testicles off before I die — right before I die, when I'm done with them and don't need them anymore — I want to cut them off myself and give them to Sheree to remember me by, and to video the whole thing, of course, and maybe charge money for the whole final performance," he suggests, before revising the idea as it occurs to him midsentence that a dead man does not need to earn a living. "But what will I need with money? Ok, fuck the money idea, what am I, crazy? I just want to cut my fucking balls off and that's that." *The Pain Journal* contains many similar moments, the author and artist grappling in real time with the idea of a post-Bob-Flanagan world in which, for him, there is no bondage, no injury, no art, no sexual pleasure, no cash, no acclaim, no love, no need for even *fucking balls*.

It made sense that he would be interested in making death itself into an artwork, an unprecedented act that would make the most perfect ending possible for his career, a fitting climax after fifteen years of edging. "I want a wealthy collector to finance an installation in which a video camera will be placed in the coffin with my body, connected to a screen on the wall," he often said, "and whenever he wants to, the patron can see how I'm coming along."

In *Sick*, he is shown expounding on this idea while ensconced in an actual coffin, a live feed trained on his face projecting him to an appreciative audience outside. "I'd be buried with a video camera, just like this, in a tomb," he says, grinning, the tight close-up of the camera and the fact that he is lying on his back making his cheeks look bloated in the half-light, as if he has already begun decaying. "And [the piece would go to] some museum or something, or one of my crazy collectors that I'm gathering." Everyone watching begins laughing, half in the hysterical and manic way that people laugh when it is not clear whether they ought to be crying, screaming, or putting a hand over their mouths with horror instead, and half because it is genuinely amusing and absurd, the sight of this ill-fated man dictating a posthumous artwork from his coffin. "It's a good way to make money before you die," he adds, perhaps not yet having come to the conclusion he reached in *The Pain Journal* about the uselessness of money for a man in his position, or perhaps deciding to omit that sober revelation for the sake of the already-pitch-black joke. "[To say] 'listen, if you pay me now, you can have the pleasure of having a monitor in your house, and the piece is called *The Viewing*, and we'll spend money to get a satellite connection, I guess, to the video monitor. And every so often someone can walk into the room and turn on a switch and see how I'm

progressing.'" Compromising, in the same year he performed this monologue, he showed a work called *Video Coffin*, a self-explanatory title for a piece that effectively recreates an open casket with the use of looping footage, a small television screen, and a standard-issue silk-lined casket. "I was promised an early death," the pretty embroidery in the lining of the coffin says, as if Flanagan might be grumbling about a delayed FedEx package or an unusually long wait for a table at a restaurant rather than about two unexpected decades of additional, unlikely life, "but here I am some forty years later, still waiting."

That bratty tone, mostly unserious, hints at the edgy impatience that animated the artist in his later, sicker years, his illness — always Damoclean — hanging over him with greater and greater precarity. "I keep thinking I'm dying, I'm dying, but I'm not," he writes, in *The Pain Journal*, "I'm not — not yet." There was something near-deranged in the propulsive mood of Flanagan's hurtling towards death, the way he seemed to taunt and dare it as if casually inviting a vampire over the threshold. When Flanagan and Rose are filmed performing the work *Autopsy* (1996) in *Sick*, for which he pretends to be dead while she inflicts various tortures on his body, we see the astounding difference between death as a burlesque, an act of play, and the real thing. Every yelp of pleasure he lets out breaks the illusion, making his very aliveness not just obvious, but extroverted. Earlier in the documentary, he reads from an obituary he has written for himself ahead of schedule, in another conceit that allows the viewer to see the dead man and the living one in simultaneous harmony, the closest thing to a real ghost that any documentarian could hope to commit to film. "Bob Flanagan, artist, masochist, and one of the longest living survivors of CF, lost his battle

this week with the killer disease," Flanagan says, stumbling at first but then recovering his composure for the actual faked announcement of his expiration, "a genetic disorder of the lungs and pancreas that both plagued and empowered the provocative performer throughout his difficult but productive life." His refusal to entirely condemn cystic fibrosis and its effect on his quality of life, choosing instead to see it as — in presciently modern parlance — "empowering" is not just defiant but punk, turning affliction into enlightening material.

"No-one returns from the dead, no-one has come into the world without weeping," Kierkegaard once wrote. "No-one asks one if one wants to come in, no-one when one wants to go out." Flanagan's desire, having been told he would have to go out earlier than most men, seemed to be to know exactly when to expect the deadeningly and dreadfully expected. It is possible, albeit not likely, that he pictured something better, somewhere over the horizon of his fast-fading mortality, although it does boggle the mind to think about what God might look like in the reality inhabited by Bob Flanagan and Sheree Rose, to say nothing of what form heaven might take for a self-identifying supermasochist. We may never know what Flanagan imagined might occur once he had died, although his parents raised him Catholic, a religious background that — as John Waters once so accurately said — allows a person to believe that sex is dirty all their life, a complication that can end up being good for the libido. "Catholics have more extreme sex lives," Waters added, "because they're taught that pleasure is bad for you. Who thinks it's normal to kneel down to a naked man who's nailed to a cross?" One possible answer is, of course, the very naked and occasionally nailed-up Bob Flanagan, who remained a small-c catholic in his broad appreciation of physical suffering, even if he did not

technically keep his faith. (Google "Bob Flanagan catholic" and, somewhat serendipitously, a reverend by the name of Robert Flanagan appears. "The Rev. Dr. Bob Flanagan," his publisher's biography notes, "has struggled with mental illness and managed to thrive for over twenty years." It seems likely that the other Bob Flanagan would have found this a hilarious coincidence.)

I suggested earlier that *Video Coffin*, in its playful invocation of an open-casket funeral, was a compromise; perhaps to say so was not fair, even if it was accurate. "Art is uncompromising," Günter Grass once supposedly said to Arthur Miller, "and life is full of compromises." Nothing a man faces in his life, it's true, is as uncompromising as the fact of death, making it — if Grass is right — perhaps de facto the most perfect work of art. It may be that this makes Christ the greatest artist of all time, since whose death has since been more analysed by fans, denounced by critics, and paid homage to by other artists? Good art, as a great number of artists have insisted throughout history, is first and foremost about sacrifice, a willingness to disappear into the medium *and* the message fully enough that life itself becomes a secondary concern.

"The progress of an artist," T.S. Eliot suggested, "is a continual self-sacrifice, a continual extinction of personality." Why not a continual, then total, extinction of the actual, corporeal self? What might it mean for an artist to die in the service of his or her art? It is difficult to know, since after many, many decades, we're still waiting to be shown what this might look like. In the documentary, it is interesting that, while we are allowed to see Flanagan drawing some of his last breaths, and we are shown his lifeless body in the hospital and then the morgue, but we do not see the actual moment of his death, as if this final catastrophic intimacy proved,

ultimately, *too* intimate for even the world's most renowned and previously death-defying pervert to reveal. Where it might once have been unthinkable to share one's sex life as an artwork, this particular disclosure has been more and more acceptable, sometimes feeling rote enough to actually be dull, since the last third or so of the previous century. To be injured for one's art, as should be clear after the previous 106 pages, is no longer impossibly taboo, either. If Flanagan had pulled off his posthumous video show, he would have been the first in history to successfully and literally make an artwork from his death, although others have come close. "I had a pistol with bullets in it, my dear," Marina Abramović told the *Guardian* journalist Emma Brockes in 2014, talking about *Rhythm Zero*. "I was ready to die." If we choose to invoke the death of the author to proclaim *Jackass*, in spite of Johnny Knoxville's protestations, a legitimate and long-running work of art — *Jackass 3D*, lest we forget, has been honoured with a screening at the MoMa — then the death of Ryan Dunn in 2011 in a car crash might be seen to be the accidental, terrible result of a life lived in total service of a single, constantly developing work centred around both risk and violence. The fallout from the creation of the *Jackass* series on a wider scale, seemingly as injurious to several of its major players' minds and souls that they may as well have been stationed in a war, has been grievous enough to prompt various articles about "the *Jackass* curse," with alcoholism, drug addictions, lawsuits, suicide attempts and psychiatric hospitalisations all being cited as examples of its power. The enhanced death drives that helped to propel the show, once as animating and heightening as the purest speed, began curdling, getting heavier and heavier to carry. The one thing that could be said for Ryan Dunn, who was just thirty-four years old and left behind a woman who

loved him, was that he had died exactly as he lived, fast and free, and in doing so had made the clearest statement about his extreme daredevilry that could be made.

When Ron Athey wrote in 2015 about an early-life suicide attempt at just fifteen, he made it clear that, even if he had not yet become an artist, he had hoped to aestheticise the event in such a way that it would also be a statement of intent, a projection of his secret inner self — a corpse as a confession. "I planned my death carefully," he recalls, writing an essay for the Walker Arts Centre about his career-long obsession with mortality and blood,

> waiting until one afternoon when no one would be home. I bathed and fixed my feathered hair, put on a tight suit and light makeup. I took 25 Valiums, 5 Seconals, and a few phenobarbitals, and lied back like a perfect corpse as the pills entered my system. Then it got real and survival instinct crept in. I managed to walk out the door and stumble down the road to a payphone and call my girlfriend, who helped me through the endless vomiting.

"Since then," he adds, "death has been a constant companion, even more so in the three decades after 1985, the year I tested positive for HIV. Until it wasn't. It's been 30 years since I was diagnosed, and I feel healthy and have rarely been sick." "Why do I choose to do this?" he had asked a little earlier, in 2013, before offering an answer: "It wasn't the fault of the art movement I never belonged to, or the sick mentors that encouraged me. It's the fault of my rotten life." By "this," he meant the extroverted, supererogatory way he chose to hurt himself in order to make art, an impulse that certainly might suggest to some that the practitioner him-or-

herself had lived through something "sick" and "rotten." An indefinable change, though, came over the older Athey as he grew from a flamboyant, closeted teenager into a charismatic queer performer. When he said "my rotten life," he referred to both his trauma, and his status as an HIV-positive man who feared he would be dead before he managed to complete his earthly work. After this, in the period in which he mentions feeling reinvigorated — a time when, as he boasted, he "still felt healthy and horny," and in which "[his] blood... was coursing" — it seemed to occur to him that he had been correct in fighting the impulse to end his life just fifteen years into its course, as if he had somehow intuited that day while lying in state on the bed in all his finery that things would alter, and that one day he would no longer see his existence as being merely "rotten," but as an ongoing opportunity to show the world that he deserved to occupy his idiosyncratic corner of it.

As is often true with contemporary art, the final taboo may not end up being broken in a gallery, but online. Videos of actual death (ISIS beheadings, the televised suicide of R. Budd Dwyer in the senate in the Eighties, videos made by the Canadian serial killer Luka Magnotta, etc., etc.) have been circulated on the internet for as long as most millennials and Gen-Z-ers have had access to it, making a bizarre 2018 incident with the young, idiotic YouTuber Logan Paul a little less surprising — albeit no less miserable or dystopian — than it might have otherwise been. Filming in the Aokigahara forest in Japan, an area known for being the site of frequent suicides, Paul came across a human body, and rather than abandoning what was meant to be an entertaining video, made the psychopathic choice to move in closer with the camera — obviously nervous, but just as obviously aware that death, like

sex, can be extraordinary for ratings. His reaction to the scene reads as profoundly inauthentic, although whether this is due to his having adopted the specific mannerisms of a YouTube vlogger, in which recognisable facial expressions are reduced to broad, cartoonish semaphore, is not quite clear: he looks as if a Disney prince has been drawn seeing a dead body for the first time, all huge eyes and grasping hands. "This is a first for me," says Paul, nodding vaguely at the corpse. "It's definitely a first for me. I'm sorry about this, this was meant to be a fun blog. Suicide is not a joke." The latter observation does not jive exactly with the fact that he is using it as content for a YouTube video for a teenage audience, and feels even less believable in light of his delivering this stirring monologue wearing a hat shaped like an alien from *Toy Story*. "I don't feel very good," one of his crew says, sounding nauseous, and Paul — seeming to forget what he has just said about suicide not being very funny — says sarcastically, "what, you've never stood next to a dead guy?" and then laughs.

Morally, Logan Paul's video is repulsive; culturally, it is fascinating for its casual depiction of real death, not contextualised in the hysterical and sensationalist mode of a mondo film, but in the half-baked, quasi-therapeutic language of most contemporary coverage of trauma, pain, and violence. "This is not clickbait, this is the most real vlog I've ever posted on this channel," Paul says, in a solemn introduction to the clip that uses "real" in two discrete and possibly opposing senses: "real" in the sense of "keeping it," invoked to suggest to his audience that he is not being exploitative but simply and accurately reporting on a serious and pertinent issue, and "real" in the more literal sense that no part of the human experience captured authentically on camera, even sex, is as conspicuous for being real as death itself. Perhaps more interestingly still,

Paul immediately circles back and, in the parlance of art criticism, revokes his suggestion of the "real" to invoke the "surreal." "This is the most circumstantially surreal thing that has ever happened to me in my life," he says, the four-syllable word and the art-historical one revealing that he either pre-prepared, or had prepared for him, a script. Surrealism, per the writer André Breton, is defined as "pure psychic automatism, by which one proposes to express, either verbally, in writing, or by any other manner, the real functioning of thought," making the image of a YouTuber stumbling on the body of a suicide an accidentally perfect example of the movement's legacy. In this un-orchestrated meeting — "as beautiful," as Breton might say, quoting the Comte de Lautréamont, "as the chance encounter of an umbrella and a sewing machine on an operating table" — between a flesh-and-blood representative of meaningless and brainless entertainment and a flesh-and-blood reminder of mortality, what emerges is a metaphor for the intrusion of the idea of death into even our most lightweight attempts to distract ourselves from our own fragility. It fits, too, David Foster Wallace's conception of the Lynchian (after David Lynch), a descriptor often used interchangeably with "surreal": "A particular kind of irony where the very macabre and the very mundane combine in such a way as to reveal the former's perpetual containment within the latter." "The [Lynchian] is this weird confluence of very dark, surreal, violent stuff," Wallace later clarified on *Charlie Rose*, "and absolute, almost Norman Rockwell, banal, American stuff."

To judge a YouTube video by Logan Paul as if it were a work of art is, on the face of it, even less sane than considering whether or not death itself can be an artwork. Still, what the jock vlogger's ill-judged visit to the Aokigahara forest managed

to achieve was a fracture in the YouTube status quo, a bleed between the mainstream and the kind of content normally found in darker and more subterranean places. "I'm pretty sure this marks a moment in YouTube history, because I'm pretty sure this has never — hopefully — happened to anyone on YouTube ever," he acknowledges, a moment before the real video begins. Pride, bright and inappropriate, emerges momentarily from behind the clouds, the sombre gloom of Paul's "sensitive" introduction briefly shown for what it is. Even if we *were* to judge the video as art, it still does not address the question of whether an artist dying for his art might be a worthwhile sacrifice, since it cannot escape even a casual viewer's notice that the man who died and ended up immortalised in *We found a dead body in the Japanese Suicide Forest* remains anonymous, and Logan Paul is still very much with us, taking up amateur boxing and hosting a podcast with the very stupid name "Impaulsive." (He has claimed that head injuries sustained playing football in his high school team have left him without the ability to experience normal human empathy, a somewhat convenient fact that he revealed only once he had made the suicide forest video and been accused of sociopathy.) It would not be the most notable example of a crossover between YouTube pranksters and real death, either, as that honour goes to what might callously be called a "lost work" by a late YouTuber with the apropos name "Damitboy."

Pedro Ruiz, a handsome twenty-two-year-old who professed a deep and abiding love of *Jackass*, had the idea of reinventing himself as an amateur YouTube stuntman sometime in 2017, partly because he admired men who had achieved renown on similar terms and partly because, if he had to be entirely honest with his audience, he and his girlfriend needed money. He and Monalisa Perez, who was nineteen at the time, had

had a baby in their teens, and were about to have another. How else could a good-looking but thoroughly unconnected boy from Halstad, Minnesota, make an immediate fortune, if not via the contemporary gold-rush of the web? How else might he stand out, if not by doing something nobody else dared to do? "The ultimate test is to see if this .50-caliber bullet will go through a book," he was recorded saying, in a video taken shortly before he and Perez staged the stunt that ultimately killed him. "I'm going to stand behind it and Monalisa is going to shoot. I hope she hits the book and not me… if I'm gonna die, I'm pretty much ready to go to heaven right now. If I die, I'll be ready for Jesus. He probably won't accept me into the pearly gates because of how stupid this is." The book, a hardback several inches thick, was not a Bible, perhaps because Ruiz trusted Perez enough with his life that he did not feel he required divine protection. Perez, heavily pregnant and afraid, appeared in the footage shown to jurors in the courtroom to be a reluctant participant in the dangerous game her lover hoped would make them famous, prevaricating and begging, obviously stricken with a terrible feeling that she might in fact be sending him to heaven. "Babe, I'm not doing this. I can't — babe, if I kill you, what's going to happen to my life? Like no, this isn't OK. I don't want to be responsible," she allegedly tells him just before she fires a .50-caliber Desert Eagle handgun at the centre of his chest. She spent 180 days in jail for second-degree manslaughter, it being obvious to the jury that what happened was nothing like murder, even if it was not technically an accident, and then emerged a nineteen-year-old widow and a single mother to two children.

"Every week I'm going to be bringing you guys new videos, crazy videos. I don't have much money. But it takes

money to do the crazy stuff I want to do. I hope with doing this YouTube, I can build a loyal audience that loves to see crazy stuff… I'm borderline crazy," Ruiz had said in the video filmed the morning of the stunt. "I just love the adrenaline… the near-death experiences. I hope I capture all my audience like [snaps fingers]. I hope with everything I do you guys can just be hooked and watch until I fail." That he believed his failure was inevitable, preordained by fate, is a touching, distressing detail, making him seem no less deliberate about the video capture of his death than Bob Flanagan or Chris Burden when they said respectively that death's approach was frustratingly creeping and mysterious, and that burning out suddenly like a comet might be preferable to waiting. Reports that Ruiz had told one of his high school friends that, if he died, he'd at least "go out with a bang" add to the general impression that, although the clip was not technically of a suicide, it was not conceived by a man who was naïve about the risk of dying, either. Because YouTube videos are not considered a real art form, and because showing a death is not permitted in accordance with its rules, Pedro Ruiz did not end up being made immortal by his video the way Chris Burden might have been if he had been killed making *Shoot*. The actual moment of Ruiz's sudden death has not been seen by anyone except those directly involved in the criminal justice aspects of the case; the incident did not earn Perez any money, only punishment and what she describes as a year-and-a-half of perpetual suicidal thoughts. Eventually, she revealed that their relationship had not been as unconditionally loving as it might have once appeared: "You have to understand," she told a local newspaper in 2021,

that I met Pedro when I was 14, and he literally molded

me into the person he wanted me to be. I got pregnant at 15 with him, and I was pregnant during the situation, too, at 19. He was very impressive to me. This sounds really weird, but I looked at him like my king, anything he said I'd be like 'OK, I'll do it.' Because if I didn't do it, he would manipulate me.

(The last tweet on Perez's twitter account, made on June 26th, 2017, says "Me and Pedro are probably going to shoot one of the most dangerous videos ever… HIS idea not MINE.") Ultimately, what was meant to be the greatest dare of all did not turn out to be art, entertainment, a successful stunt, or the beginning of a fortune, only a terrible, senseless waste of life.

When art critic Peter Schjeldahl learned that he was close to death, he did what he would do with any other act of great emotional and theoretical significance and wrote about it, in an essay for the *New Yorker* he called "The Art of Dying." Like Pedro Ruiz, he grew up in Minnesota, and like Ruiz he had once thought dying "fast" might be the best thing for a man. He changed his mind once death became a concrete possibility. An extraordinary text, "The Art of Dying" spans the entirety of the writer's life, up until his diagnosis with lung cancer at the age of seventy-seven. "Death," he says, "is like painting rather than like sculpture, because it's seen from only one side… A thing about dying is that you can't consult anyone who has done it. No rehearsals. No mulligans." He finds that being terminally (or probably terminally) ill affords him the ability to produce something "for himself," after a life spent writing only criticism in the wake of an unfortunately unsuccessful poetry career — he quotes Samuel Johnson, who once said that "when a man knows he is to be hanged in a fortnight, it concentrates his mind wonderfully." It is fascinating to

see death being used as inspiration by a critic in lieu of an artist, Schjeldahl pointing out that, as a subject, it is perfectly aligned with his "unreconstructed reverence for extreme states of mind and feeling." That same reverence was what drew him to Chris Burden, and it also meant that death itself often appeared in his analysis of works by numerous artists. "Death is the perfect subject in [photography]," he suggested in the *Village Voice* in 1997, paraphrasing the photographer James Hamilton, on the grounds that it is "surefire arresting." "His art became funerary," he wrote admiringly about Jeff Koons in 1992, "immortal because deathly." This suggestion — that to die is to attain the only possible form of eternal life, not theologically or spiritually, but conceptually — reappears in "The Art of Dying": "Life doesn't go on. It goes nowhere except away. Death goes on. Going on is what death does for a living. The secret to surviving in the universe is to be dead."

"I've never kept a diary or a journal," he suggests at one point in his self-authored, pre-emptive eulogy, "because I get spooked by addressing no one. When I write, it's to connect." It is impossible not to immediately think about Bob Flanagan's *Pain Journal*, written for an audience that would not read it until after he had died. Both Flanagan and Schjeldahl ran in the same circles in the Eighties, and both men were poets; in a list of Flanagan's effects, it is revealed that he owned Schjeldahl's poetry book *Brutes*, published by their mutual friend-or-acquaintance Dennis Cooper. At the time of writing, Schjeldahl has joined Flanagan in outliving the expectations of his doctors, not yet having been killed by the "rampant" cancer he described in 2019. Both men, captured in full, passionate flow about their respective endeavours, cannot help but impress audiences with their tireless strength. In a scene in *Sick*, Bob Flanagan's parents sit beside each other at

the kitchen table and attempt to make sense of the way their son has managed to extend his life by sacrificing himself on the altar of dangerous masochism: they are shell-shocked and confused and haute-suburban — Robert Sr in beige chinos and a button-up polo shirt, and Kathy with her white hair in a perm — but at no point do they waver in their adoration of their atypical, countercultural son. "Did we only give him love when he was in pain?" Kathy asks, before acknowledging that this could only be the case because "he was in pain so much of the time." The question hangs there, like a masochist hanging up by his wrists. Eventually, Flanagan's father launches into an affecting explanation of the way he sees his son's approach to S&M using an allegory about acrobats, and what he says is so intensely moving that it cannot help but catch the viewer off his or her guard, a feeling like missing the bottom step on an especially steep staircase or — like Robert Sr might say — like not quite catching the bar on a high trapeze. "A man [on] a trapeze," he says, confidently, his large hands moving in circles,

he does this twisting and turning, and he does a tumble on the trapeze, and then he lands perfectly on his feet. And when I see him twisting and turning, I get excited — I get scared, I get that fear that he's gonna fall. And it's the same with [Bob] when he sticks the needles in himself: I feel the pain. Then he lands on his feet, and I'm proud, and all of a sudden everybody's applauding… I think he's doing this to say to God, or whoever's out there: you son of a bitch. What you've done to me? I'll show you — I'll do my tumble, and I'm coming back at you. This is my way of telling you to go fuck yourself.

Calling "God, or whoever's out there" a "son of a bitch" is, on some level or another, what every practitioner whose work is detailed in this book is trying to do — to fly in the face of safety, comfort, longevity and actual sanity in favour of experiencing or projecting exactly the kinds of "extreme states of mind and feeling" Schjeldahl is bewitched by. If the moment of Bob Flanagan's death is not available to us, he still produced a staggering body of work about the twin experiences of suffering and dying, the kind of unflinching reportage that is unusual and valuable enough to ensure that the man behind it is remembered fondly and indefinitely. (Going on may be what death does for a living, but the same can be said of the greatest art, the soundest theory, the most evocative writing — a body of work can, after all, outlast a body.) It is not even required of us to wonder why he did the painful things he did, since in the 1985 poem "Why," he lists his own personal reasons for his love of being hurt, some amusing and some poignant, some indicative of his sophisticated self-awareness and some flippant: "Because there was so much sickness"; "Because I say 'fuck the sickness'"; "Because of Christ and the Crucifixion"; "Because of what's inside me"; "Because of my genes"; "Because I felt like I was going to die"; "Because it makes me feel invincible"; "Because my parents said 'be who you want to be'"; "Because of hammers, nails, clothespins, wood, padlocks, pullies, eyebolts, thumbtacks, staple-guns, sewing needles, wooden spoons, fishing tackle, chains, metal rulers, rubber tubing, spatulas, rope, twine, C-clamps, S-hooks, razor blades, scissors, tweezers, knives, pushpins, two-by-fours, Ping-Pong paddles, alligator clips, duct tape, broomsticks, barbecue skewers, bungie cords, sawhorses, soldering irons"; "Because it's against nature"; "Because it's in my nature"; "Because no pain, no gain," and so on. Most interesting is the poem's

final line, which hints at a radical form of self-acceptance on the part of its creator, a once-and-for-all verification of the way that he maintained a relationship with his body that was not straightforwardly combative, but more often earnestly appreciative: "Because you always hurt the one you love."

REPEATER BOOKS

is dedicated to the creation of a new reality. The landscape of twenty-first-century arts and letters is faded and inert, riven by fashionable cynicism, egotistical self-reference and a nostalgia for the recent past. Repeater intends to add its voice to those movements that wish to enter history and assert control over its currents, gathering together scattered and isolated voices with those who have already called for an escape from Capitalist Realism. Our desire is to publish in every sphere and genre, combining vigorous dissent and a pragmatic willingness to succeed where messianic abstraction and quiescent co-option have stalled: abstention is not an option: we are alive and we don't agree.